IMAGES
of America

AURORA

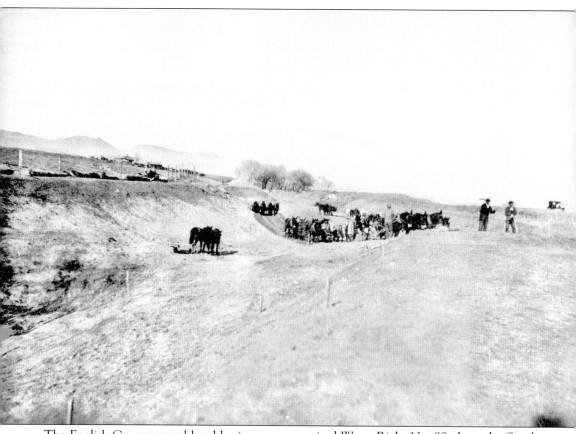

The English Company and local businessmen acquired Water Right No. 88 along the South Platte River. They planned to canal the water from the Platte River at Waterton Canyon to the plains. It was named the High Line Canal because it followed the high contour of the land so the water would naturally flow to the high plains. It is considered a marvel of Victorian engineering. (Courtesy Aurora History Museum.)

ON THE COVER: Bright sunshine illuminates this scene representing life in Aurora in 1940. Though it was constantly growing, it retained the small-town feel that made so many servicemen and their families feel at home. Residents fondly recall times at the Yucca Bar and Restaurant across the street, which for many years was a landmark on East Colfax Avenue. (Courtesy Aurora History Museum.)

IMAGES

of America

AURORA

Sherah J. Collins

ARCADIA
PUBLISHING

Published by Arcadia Publishing
Charleston SC, Chicago IL, Portsmouth NH, San Francisco CA

Printed in the United States of America

Library of Congress Catalog Card Number: 2007931266

For all general information contact Arcadia Publishing at:
Telephone 843-853-2070
Fax 843-853-0044
E-mail sales@arcadiapublishing.com
For customer service and orders:
Toll-Free 1-888-313-2665

Visit us on the Internet at www.arcadiapublishing.com

For J. C. and J. P.

CONTENTS

ACKNOWLEDGMENTS

I would not have been able to complete this project without the many people who gave their time, support, knowledge, and encouragement.

First of all, I would like to thank the Aurora History Museum for graciously allowing me the use of its archives, without which this book would not have many of the interesting photographs reprinted here or the information you will read on these pages. All of the images belong to the museum unless otherwise noted. I am forever grateful to Michael Thompson, curator of collections, for his time and assistance.

My mother, Gail Newcomb, instilled in me a love of history at an early age. Her help and encouragement have been invaluable in completing this work. My father, David Newcomb, and my brother, Jason Newcomb, helped me immensely in multiple ways.

I would like to extend a very large thank-you to those who allowed me to interview them: Paul and Kate Tauer, Elisabeth Watson, Juanita Sparks, Margarete Gamucello, Twyla Gaugenmeier, Ruth Creel, Dave and Evelyn Chase, John Dale, Annabelle Dunning, Bob Eide, and Ruth Fountain.

And last but most definitely not least, I am grateful to my editor, Hannah Carney. She has been encouraging, patient, full of good advice, and a joy to work with.

This book is for everyone who has been a part of Aurora's history and who has helped to preserve it. It is intended to be a general look into Aurora's past, showcasing snapshots of life over the years.

INTRODUCTION

Before white men set foot on the land that later became Aurora, it was an empty, vast prairie that stretched between the Rocky Mountain chain and the fertile hilly region farther to the east.

The environment was too dry to sustain any significant amount of vegetation. The only thing that grew in abundance was coarse, yellow buffalo grass. There were a few creeks that meandered through the area, rising from springs and usually carrying thin streams of water, although heavy rains and snowmelt would swell the waters into a rushing torrent on occasion. Cottonwood, willow, box elder, sagebrush, and scrub oak used to grow around the streams. The topsoil consisted mainly of a poor-quality, fine-grained dirt prone to wind and water erosion. The prairie grass formed a carpet for the ground, keeping the dirt in place despite the fierce winds that continually swept over the land. This protective covering was later destroyed by settlers as they plowed the grass under to make way for their crops, leaving the ground exposed to the elements.

It was—and is—a place of severe contrasts in the weather. In the summer, the sun bakes the ground until the grass crackles underfoot. In the winter, blizzards and high winds strike. Rainfall has always been scarce, averaging a mere 14.81 inches per year.

In spite of the sparse plant life, many varieties of animals have lived on the plains. Antelope, deer, buffalo or American bison, and elk formerly roamed the prairies in large herds. Smaller animals included the gray wolf, coyote, ground squirrel, rattlesnake, jackrabbit, and cottontail rabbit. Birds such as prairie chickens and wild turkeys nested among the grasses along with migratory birds like ducks and geese.

The first people to inhabit the area were some of the Native American tribes of North America. They lived nomadic lives, camping on the dry plains to hunt. The Jicarilla Apache and Pawnee tribes controlled most of what is now northeast Colorado. In the early 1500s, Spanish explorers came to Colorado in search of Cibola, the fabled seven cities of gold. With their arrival, the land was claimed by the Europeans, and significant changes began to take place.

The Native American tribes now possessed horses and guns—things that had been unheard of before the explorers came. Territorial struggles over the hunting grounds in northeast Colorado rose and continued until the Cheyenne and Arapahoe tribes settled their dominance in the area in the 19th century.

In 1803, Pres. Thomas Jefferson signed a document that would forever change the destiny of this bare land. It was the Louisiana Purchase, which of course included several Western states along with all of what would become Aurora. Lt. Zebulon Pike led an exploration of the area in 1806. Pike's Peak, which can be seen from southern parts of Aurora, was named for him. The next individual of note was Maj. Stephen Long, who followed the South Platte River until he came to the Smoky Hill Trail on his way to the Rocky Mountains. He called the plains "the Great American Desert," a sentiment echoed by Pres. Ulysses S. Grant on a visit to Denver years later.

The reason Aurora was eventually nicknamed the "Gateway to the Rockies" was because it was the first place one would encounter on the way to Denver and the vistas beyond.

At first, white men came only in trickles under the hot sun, following the trails near the North and South Platte Rivers on their way to the mountains and beyond, most seeking gold or adventure. *Gold* was one word that soon led the white men to the future site of Denver/Aurora in droves. William Green Russell was responsible for causing the craze in 1858. He and his friends found gold along Cherry Creek and the South Platte River, and the news spread like wildfire on a hot summer day.

The slogan became "Pikes Peak or Bust," and since the gold was mainly on the surface (called a placer mine), it became simply "Bust" for the majority of the daring adventurers. Many of them followed the Smoky Hill Trail until it intersected with the path dubbed "the Golden Road," later becoming Colfax Avenue.

The Smoky Hill Trail separated into three branches on its way to Denver at the site of present-day Limon. The northern branch roughly followed Colfax Avenue, while the southernmost ran along what is now Parker Road. Some of the outposts along the trail included the Nine-Mile House, Twelve-Mile House, Seventeen-Mile House, and the Tollgate stage stop. The latter was operated by the Delaney family at one time. The middle trail was called the Smoky Hill Middle Trail or Starvation Trail and was approximately where Smoky Hill Road is today.

The route was hazardous and arduous, giving rise to the nickname "Starvation Trail," true to American originality. However, this did not stop travelers from making the trip.

The exodus in the mid-1800s created the city of Denver, also called the "Queen City of the Plains," which sprang up almost overnight, like many other Western boom towns. The same year gold was found, Arapahoe County was formed. It was part of the Colorado Territory, which became the state of Colorado almost 20 years later, in 1876, with Denver chosen as the capital.

Civilization quickly took a firm hold on the rolling hills that sloped from the Rocky Mountains. As early as March 9, 1859, the first stagecoach left Leavenworth, Kansas, bound for the settlements by Cherry Creek. Linking Denver with the east via telegraph lines was accomplished a few years later, in 1863.

Sand Creek, one of the streams that flowed through the future site of Aurora, was the site of a tragic massacre in 1864. A Native American war party had raided the Hungate House, and in retaliation, Gov. John Evans led the attack on a Native American camp in November. This resulted in a war between the settlers and the tribes that did not stop until 1869, when the Battle of Summit Springs was fought in northeast Colorado near Sterling and the remaining Native Americans were removed to the Indian Territory.

Denver had been left out of the nation's first transcontinental railroad line, much to the dismay of citizens and city leaders. As a result, the Denver Pacific and Kansas Pacific completed routes that linked the city to the east in 1870.

The scarcity of water was becoming an increasing problem as more farmers arrived in the area to homestead the land east of the mountains. The English Company, formed by a group of English, Scottish, and American investors, undertook several irrigation projects, the most well-known being the High Line Canal. Work was begun in 1880 and completed in 1883, at which point water was brought from the mountains to the high plains.

Since Denver had become more accessible with the railroad routes, it experienced steady growth, and realtors began to take advantage of the booming market. About this time, developers looked to the empty plains east of Denver as a possible location for a fashionable district. Thus was issued a new era for the land that became Aurora.

One

FOUR SQUARE MILES

The land to the east of the Rocky Mountains was still vastly undeveloped in the 1880s. Scattered in wide open spaces were a few farmers such as the Gully family, whose land stretched along the Tollgate Creek. The area along the South Platte River enjoyed a real estate boom as more people moved west. The mines located in the mountainous regions of the state turned out valuable silver, gold, and lead. Silver boosted Colorado's economy tremendously, as the majority of it was shipped overseas to make coins, most notably the Indian rupee.

Denver was connected to the railroad by the Denver Railroad Company and the Union Pacific Railroad Company. Many people traveled from the East seeking adventure, the start of a new life, or an improvement in their health. One such person, Donald Fletcher, after working four years with the railroad company, opened a real estate office in Denver on Grant Street with his partner, O. R. Burchard. Together they built a profitable business. The *Denver Times* hailed Fletcher a man of high character, praising him for his honesty and moral fiber. He next looked to the high plains east of Denver—a perfect place for those who wished to live away from the bustle of the big city.

Fletcher and his associates purchased four square miles east of Denver and platted them into parcels to be resold. The sections included Boston Heights, New England Heights, Aurora Subdivision, Lincoln Club, Brooklyn, and Colfax Villa, among others. Some of his associates were Thomas Hayden, Jay J. Joslin, Charles Kountze, and Samuel and Frank Perry. The developers built wooden sidewalks along Colfax Avenue and Galena, Chester, and Elmira Streets. An advertisement for the development touted Aurora as "the Most Popular Subdivision Ever Placed on the Market." Rapid transit to Denver with a 5¢ fare to residents, running water, electric lights, and trees were guaranteed.

The venture probably would have been highly successful if a country across the ocean had not made a decision that affected Colorado as well as Fletcher. In June 1893, the Herschell Committee of the British Parliament submitted a report recommending that Her Majesty's Indian mints cease the coinage of silver rupees. This was Colorado's main silver market. Consequently, the price of silver plummeted as the foreign market closed. Many of Colorado's silver mines were shut down, some banks failed, and real estate became worthless.

Even Donald Fletcher and his family suffered. He left the Denver area, penniless once again, and in his wake, he left a momentous debt for the people of his namesake town. The water company they had purchased from him and his associates proved to have no water—yet. The townspeople found themselves saddled with the water bond's debt, which was not satisfied until well into the 20th century.

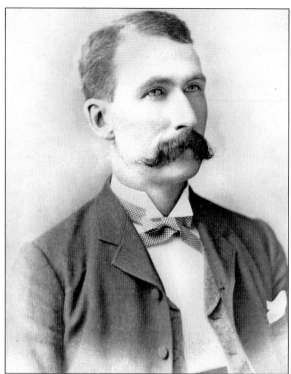

Donald Fletcher, a Presbyterian minister from Chicago, migrated west because of ill health. When he arrived in 1879, he was 30 years old and penniless. He found a job as a clerk in the offices of the Denver and Rio Grande Railroad, later opening a real estate office in Denver. He masterminded the formation of the town of Fletcher. (Courtesy Colorado Historical Society, F32,356. All rights reserved.)

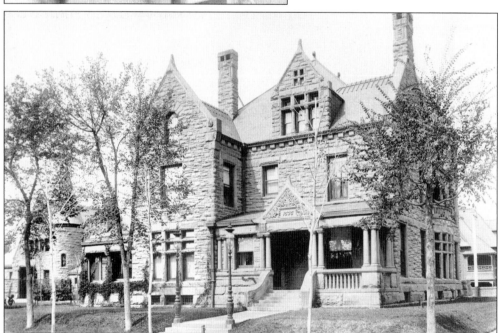

Located at 1575 Grant Street in Denver, Donald Fletcher's house was renowned for its extreme luxury. The walls were finished with oak, mahogany, and cherry wood. The mansion boasted an art gallery and a top-floor skating rink. It took Fletcher several years to complete, and unfortunately he was forced to sell it soon after completion, following his bankruptcy after the panic in 1893. (Courtesy Denver Public Library, Western History Department.)

Samuel Marston Perry served as president of the Colfax Trust Company and, along with his brother Frank, participated in Fletcher's venture to build a town. The partners built the Colfax Electric Railway, which connected the town of Fletcher to downtown Denver. Perry later sold the railway to the Denver Tramway Company, where he also was vice president for 40 years. (Courtesy Aurora History Museum.)

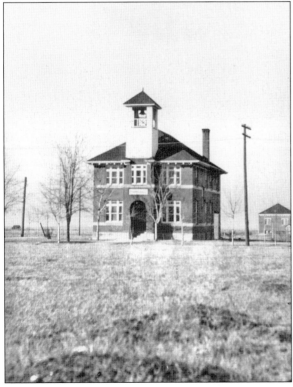

Myron Van Buren gave a parcel of his land to the town for the purpose of building a town hall, with the condition that he be allowed to use it for 10 meetings a year at no charge. The site was on the corner of Sixteenth Avenue and Elmira Street. The first event in the completed building, held in December 1906, was a Hard Times ball. (Courtesy Aurora History Museum.)

11

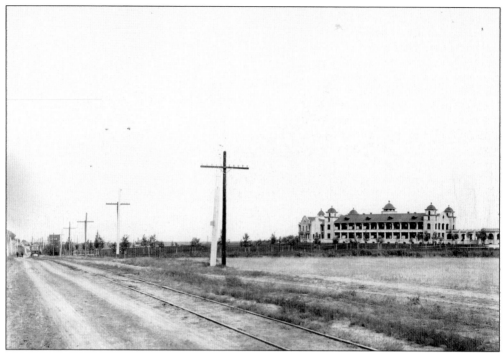

In 1906, an ordinance was passed during a town meeting to open up a sanitarium "for nervous needs." In response, the Agnes Phipps Memorial Sanitarium was built that same year. This hospital was in service until the 1930s, when it was converted into a training school for the pilots at Lowry Field. (Courtesy Aurora History Museum.)

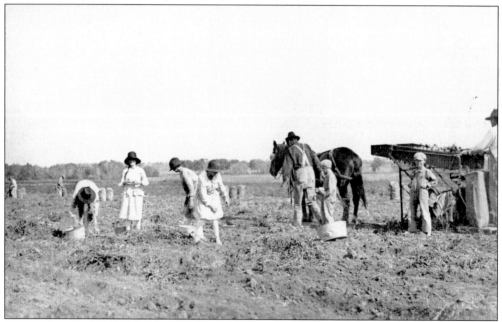

Aurora farmers and their families pick potatoes, another crop that became popular at the start of the 20th century. Some of the land that became the Hoffman Heights area, near Sixth and Potomac Avenues, was originally potato fields. (Courtesy Aurora History Museum.)

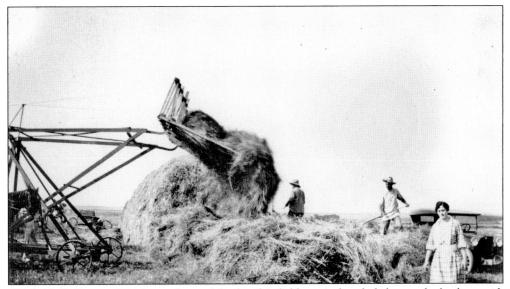

Elizabeth Gully stands in front of one of the family's fields as workers bale hay in the background. The Gullys were some of the first people to arrive in the area, building their home by Tollgate Creek during the 1860s. The family was an important part of the community. (Courtesy Aurora History Museum.)

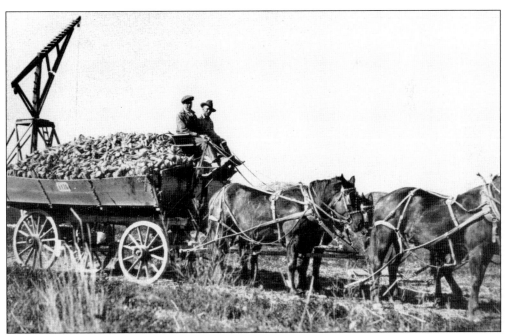

Max Maul sits in his wagon, hauling a load of sugar beets to the dump close to the present Sable Avenue. Sugar beets became one of the many crops grown in the fields around the town of Fletcher in the early years of the 20th century. (Courtesy Aurora History Museum.)

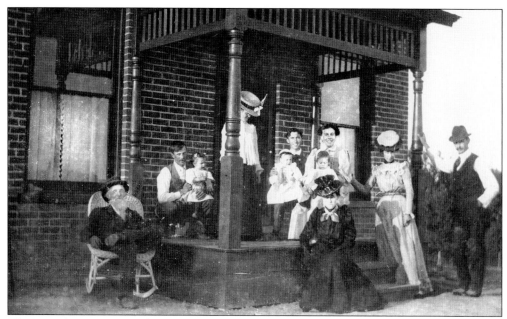

The Levenhagens pose at the family homestead, which was located in what became part of east-central Aurora. They were some of the first homesteaders in the area. Pictured from left to right are Grandpa Wood, Will Levenhagen holding Laura, Maude Thompson, Herbert Thompson holding Stuart, Sadie Levenhagen holding Willie, grandma Laura Wood, Mary E. "Dolly" Leonard, and Dudley Leonard. (Courtesy Aurora History Museum.)

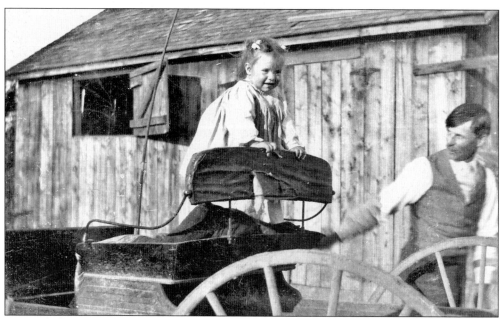

Laura Levenhagen, about two or three years old, sits on a buckboard, a common form of transportation on Aurora farms. She and her father, Will Levenhagen, appear in front of the family's stable, which stood at the present site of 2226 Galena Street. The photograph was taken at the start of the 20th century. (Courtesy Aurora History Museum.)

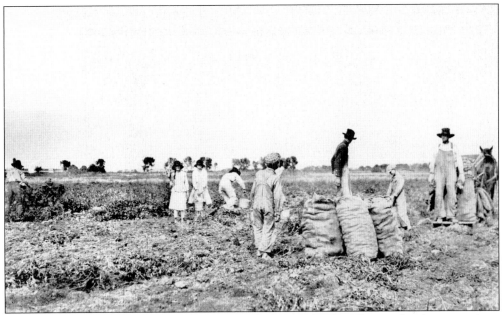

The Loudermilks often helped harvest crops with the Mauls. Here the two families are picking potatoes in a field that would become part of Hoffman Heights. Mr. Loudermilk and his two sons later started the Loudermilk Construction Company. The Loudermilk Bakery, located in the Hoffman Heights Shopping Center in later years, is also thought to be owned by them. (Courtesy Aurora History Museum.)

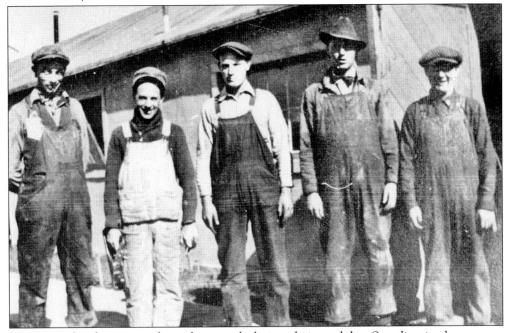

The Hoery brothers pause for a photograph during their workday. Standing in the sun are, from left to right, Theodore, Frederick, William, and Edward. The man standing on the right is unidentified. They are in front of Bill's Milk Depot on Sixth Avenue sometime in the 1930s. (Courtesy Aurora History Museum.)

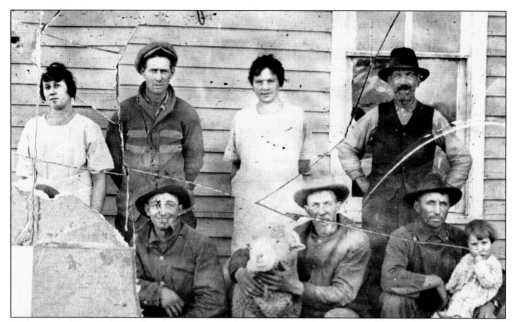

A few members of the Hoery family pose in 1919 in front of the old bunkhouse that was situated close to Chambers and Smith Roads. Pictured from left to right are the following: (first row) Frederick Hoery, William Hoery with a sheep, and Edward Hoery holding Helen Scott; (second row) Millie Lehman, Walter Scott, Helen Scott, and grandpa Robert Hoery. (Courtesy Aurora History Museum.)

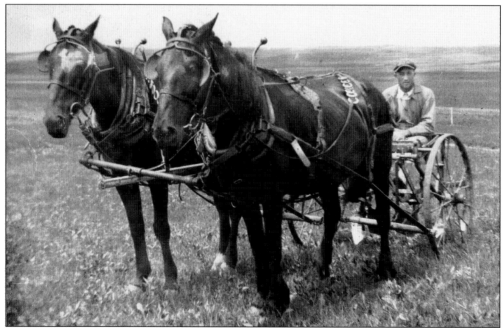

William, Robert Hoery's oldest son, purchased land from William Smith, who had bought it from Robert Gunson. The elder Hoery had formerly leased the land. The farm was approximately 320 acres, its borders roughly outlined by the modern streets of Sable Boulevard, Chambers Road, East Colfax Avenue, and Sixth Avenue. (Courtesy Aurora History Museum.)

William Smith's first frame home was torn down to make way for the large brick house that was built near the High Line Canal in 1910. The stately brick home still stands at 412 Oswego Court and has been designated one of Aurora's historical landmarks. Visible from the front of the house is the back garage, a separate building constructed in the same brick as the house. (Courtesy Aurora History Museum.)

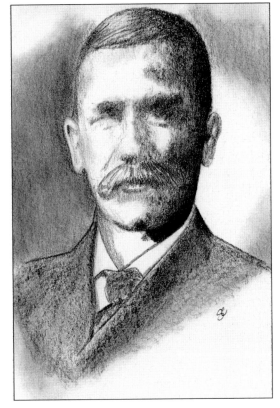

Immigrating to America from Liverpool, England, William Smith purchased land along the High Line Canal in 1882. There were no schools at the time, and he saw the need and rose to the challenge. He rode miles on his horse, calling from house to house, gathering signatures to petition the town for a local school. He even donated some of his property to the city for a small school that was attended by local children for several years. (Courtesy Aurora History Museum.)

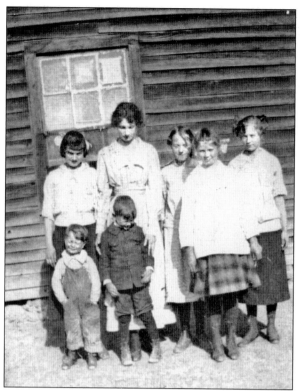

Primarily, the only academic education available for children in the area was that of the small independent schools that sprung up where there was a need. Usually young women would take it upon themselves to teach in these schools. Here teacher Mary Gully is pictured with her class at an unidentified local school. She was the daughter of John Gully and sister of Elizabeth Gully. (Courtesy Aurora History Museum.)

The Gully house, the oldest extant dwelling in Aurora, originally stood near Chambers Road and Mississippi Avenue. This interesting tidbit was published in the February 1910 *Aurora Democrat-News*: "John Gully of Tollgate met with quite an accident last week. He hurt himself by running the prongs of a pitchfork into the side of his head. He was not seriously injured, however." (Courtesy Aurora History Museum.)

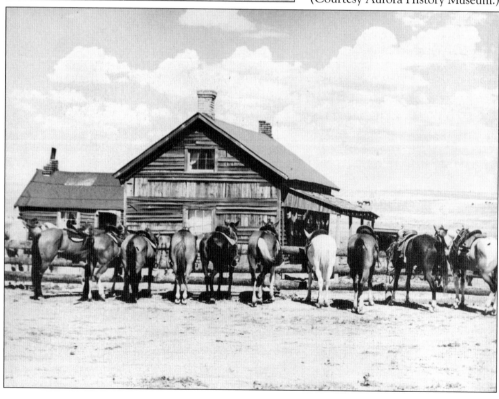

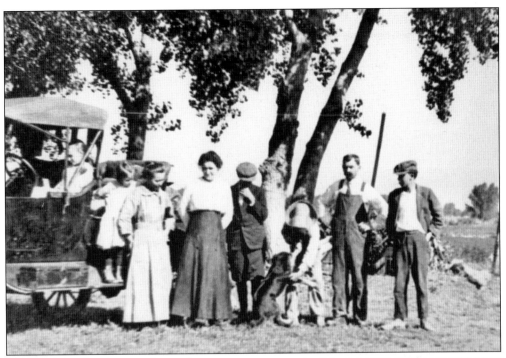

The Maul family relaxes in front of cottonwood trees in the early 1900s while on a summer picnic. Trees were cultivated to help break the high prairie winds on Western ranches and farms. The large number of cottonwood trees later gave their name to the Maul land, called Cottonwood Farm. (Courtesy Aurora History Museum.)

Harvey Hamilton Nickerson was born on January 3, 1874, in Fairbury, Nebraska, and worked as a roadbed section boss for the railroad. He died at St. Luke's Hospital on November 29, 1937, and was buried in Fairmount Cemetery. He was the oldest son of Richard Newell Nickerson. (Courtesy Elmer B. Jenkins.)

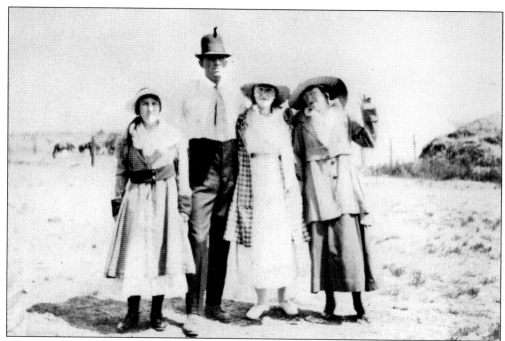

The Nickersons pose on family land in the early 1920s. The corner of their property was adjacent to Alameda Avenue and Havana Street. Shown from left to right are Gertrude, Harvey, Helen, and Anna Nickerson. Their house is just outside the frame to the left. (Courtesy Elmer B. Jenkins.)

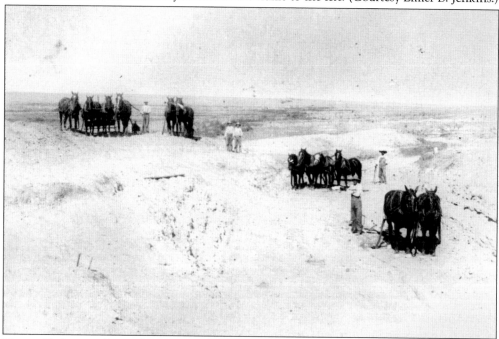

Harvey Nickerson obtained property through his work for the railroad. His pay upon leaving the company included a homestead option of Colorado land. He chose Section 13 (his lucky number), Township 4, South Range 67, west of Sixth Avenue in Arapahoe County. This eastward view shows Nickerson in the foreground with his horse and mule. (Courtesy Elmer B. Jenkins.)

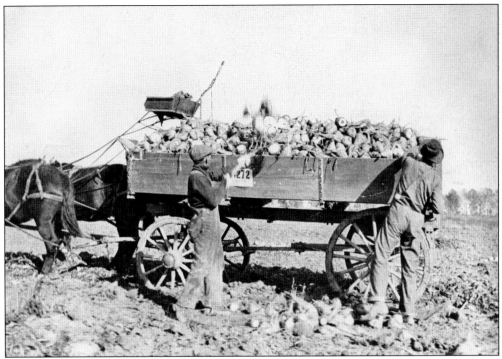

Leonard (left) and William Hoery load beets on the Tollgate Creek Ranch in 1918. Their father, Robert, came to America from Germany, married Kate Pellen of New Orleans, and moved his family west. His love of gardening and working outdoors was passed on to his children, who worked the farm for many years. (Courtesy Aurora History Museum.)

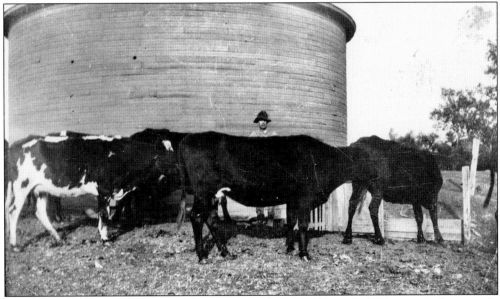

John Delaney and his well-known round barn are shown in this early-1900s view looking south. While running the Tollgate Station on the Smoky Hill Trail, he also raised cattle. Restored in later years, the barn sits in what is now the Delaney Historic District (formerly the Bresnahan property) along Chambers Road. (Courtesy Aurora History Museum.)

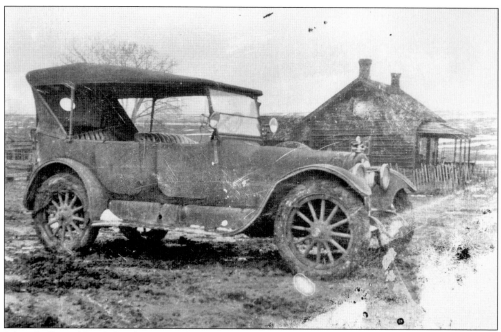

John Gully and his father homesteaded to the east of Denver long before speculators began buying up plots of land to create the town of Fletcher. The Gully family automobile, a 1920s touring car, sits in front of the original house, built about 1863 at the future corner of Chambers Road and Mississippi Avenue. (Courtesy Aurora History Museum.)

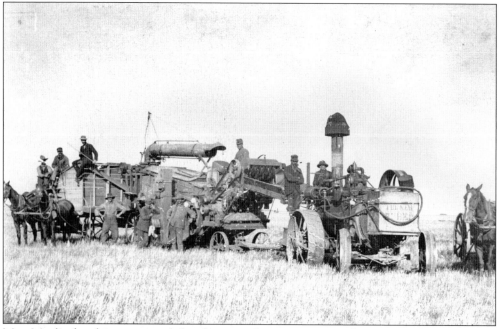

Max Maul's threshing crew and threshing machine are seen in this c. 1916 photograph. By 1911, Maul had begun farming the land for the Montgomery Land Company, owned by Albert Montgomery. The ranch extended from what is now Thirteenth Avenue to Sixth Avenue and from Peoria Street to Potomac Avenue. (Courtesy Aurora History Museum.)

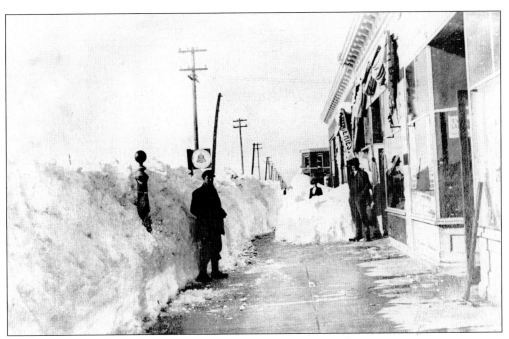

Colorado has always had severe changes in weather. The plains were sun-baked in the summer and frozen by icy winds and snow in the winter. During the winter of 1913, a blizzard hit the northern part of the state, blanketing it with several feet of snow. (Courtesy Aurora History Museum.)

Judge Alfred Harry Gutheil owned the property at the corner of Colfax Avenue and Peoria Street. Advertisements for Gutheil's Park and Nursery can be seen in the pages of the early *Aurora Democrat-News*. He sold trees and shrubs to residents and those traveling from Denver. He conducted experiments and also developed a fumigation process that would later become a requirement for all nurseries. (Courtesy Aurora History Museum.)

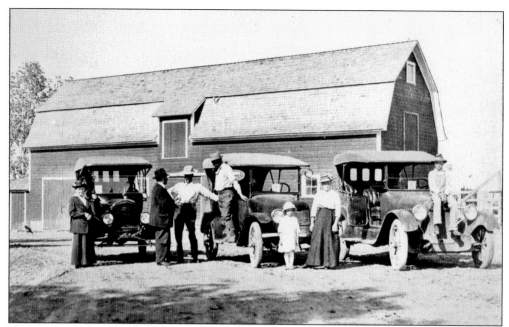

The location of the Mauls' barn was at the corner of today's Eleventh and Racine Streets. The two gentlemen and lady on the left are unidentified. Max K. Maul stands on the center car's running board. Maul's daughter, Esther, and his wife stand next to him. Max Jr. is on the right, sitting on the radiator of the car. (Courtesy Aurora History Museum.)

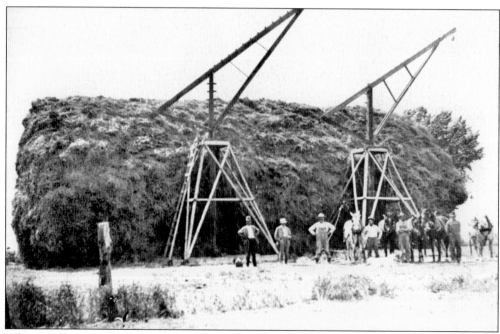

When the price of wheat and other grains plummeted, alfalfa became one of the major crops grown in the area. Many of the farms in Aurora grew alfalfa for the dairy cows that were raised. Neighbors gathered together to help each other with harvesting. Pictured is the haystack on the Maul farm. (Courtesy Aurora History Museum.)

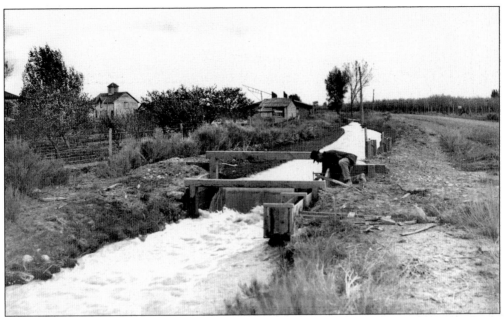

On a farm near the Denver and Rio Grande Railroad, this irrigation ditch shows the head-gate method of diverting water from the main ditch into a smaller one, to get the much-needed moisture to dry land. Many farmers diverted water from local creeks throughout the century. (Courtesy Colorado Historical Society, Engineering.F.30.936. Original photograph by George Beam, all rights reserved.)

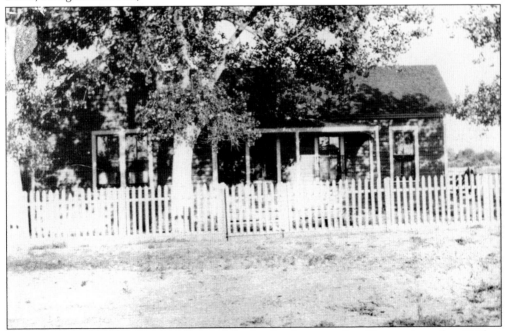

The Delaneys lived close to the Gullys, and the families became related by marriage when Bridget Gully wed John Delaney. Incidentally, the remains of buildings that belonged to both families have been restored and are now located on the same property along Chambers Road. (Courtesy Aurora History Museum.)

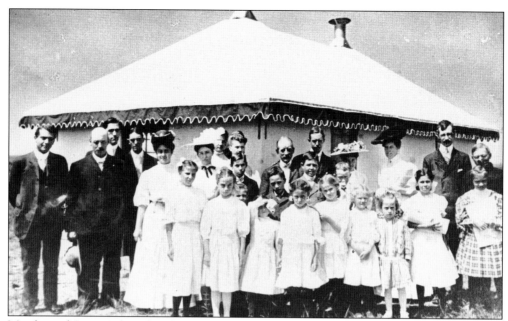

Members of Aurora's first church assemble in front of their tent in May 1907. The congregation began as the Murray Presbyterian Church but changed its name to the First Presbyterian Church soon after organization. Severe prairie winds blew the tent down, and members met in the town hall until they were able to build their own building. (Courtesy Aurora History Museum.)

Raphael Gwynn, like many others, came west to improve his health. His first issue of the *Aurora Democrat-News* was printed in December 1909. The paper was only a few pages but covered world, national, and local news. A section entitled "Social News" told the happenings and whereabouts of townsfolk. From this, one could learn who had spent Sunday afternoon with whom, who had been on a trip to Denver, and all the bits and pieces of the latest gossip. This photograph was taken one year after the newspaper was founded. (Courtesy Aurora History Museum.)

Two

A NEW START

At the start of the 20th century, things began to look up for Aurora citizens. The *Aurora Democrat-News* reported, "Three years ago property on Colfax Avenue could be bought for $35 to $75 a lot. It now brings $350."

By end of 1914, a decision had been reached about the water bonds issue. In April 1912, the U.S. Circuit Court of Appeals had ruled that Samuel J. Hickman of Westchester, Pennsylvania, was due $180,000 from the Town of Aurora as a result of the town's failure to pay the bond issue of $150,000 voted in 1891. The supreme court ruled that Aurora must pay the bonds, and in January 1916, Judge Lewis ordered Aurora to pay $25,000 of its debt or he would send its governing officers to jail for contempt of court.

A plan was outlined by town attorney Luke J. Kavanaugh in a public meeting. It called for the substitution of four-percent refunding bonds for the judgments then pending against the town. Those judgments were drawing eight-percent interest. Town officials calculated it would require a tax levy of 50 mills and it might take 50 years, but Aurora would be free of debt. The people approved of the plan, and it was ratified 106-1 two days before Christmas in 1916.

For the second time, events transpiring an ocean away would greatly affect Aurora. With the outbreak of World War I, the so-called "War to End All Wars," new tactics were being employed by both sides. The use of mustard gas caused pulmonary illnesses in many soldiers, and the need for more stateside hospitals became apparent. This paved the way for Fitzsimons, an army hospital that would have a profound influence on Aurora's future.

Raphael Gwynn, editor of Aurora's first newspaper, is pictured in his office a few years after his arrival in Aurora. Not only did he publish the *Aurora Democrat-News*, but he also printed a paper for citizens living on the other side of Colfax Avenue in Adams County. The periodical was named the *Adams County News*. (Courtesy Aurora History Museum.)

A longtime Aurora businesswoman, Lucy Chapin worked tirelessly through 1933 attempting to keep the Aurora National Bank from going under. When auditors found the bank insolvent, Lucy headed up the effort to reorganize it. She spent considerable time in Washington while the depositors' petition was making its way through the Treasury Department. Though federal officials were reluctant, the bank was reorganized in December 1933. (Courtesy Aurora History Museum.)

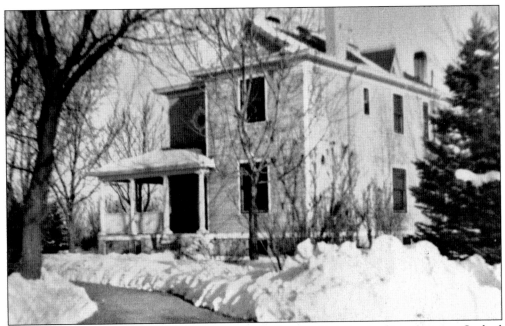

Judge Gutheil's nursery was a popular place for picnickers and strollers in the springtime. Gutheil sold the property to the City of Denver when the army was considering a local site on which to build a recuperation camp. When the army took over the premises, the former Gutheil home became the residence for the commanding officer. (Courtesy Aurora History Museum.)

Rose M. King poses in her Sunday best in front of the clapboard house that she and her husband built shortly after their marriage in 1907. Edward King was a traveling salesman for a lumber company, but he still took the time to supervise the construction. Later a larger brick house was erected for the couple. When her husband suffered a stroke, Rose took in 135 tubercular boarders for several years to pay for the home. (Courtesy Aurora History Museum.)

After purchasing an airplane kit, Auroran brothers Frank and Jules Vandersarl built one for themselves soon after the Wright brothers had gone on their famous flight. "Barn hopping" became a popular pastime, and individuals would pay the brothers for a ride in their plane. Frank Vandersarl wears his pilot's uniform in this photograph. (Courtesy Aurora History Museum.)

William Hoery is shown here with his John Deere tractor, which cost him and his brother Fred $500 each. William was born on July 1, 1888, and ran the family's farm for 35 years in addition to the dairy store he opened in the 1930s. (Courtesy Aurora History Museum.)

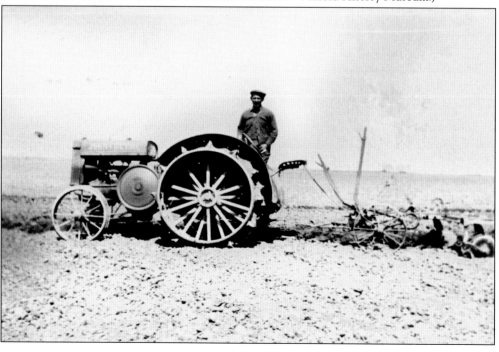

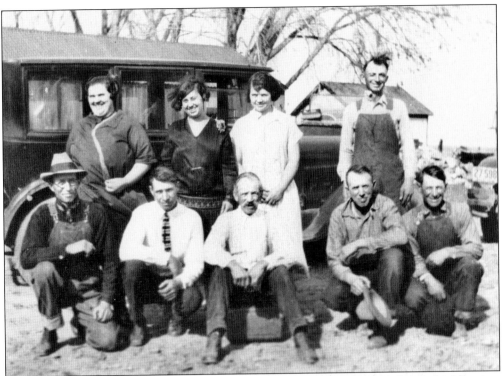

The Hoerys pose in 1927 in front of their 1925 Dodge. Pictured from left to right are the following: (first row) Edward, Theodore, grandpa Robert, William, and Leonard Hoery; (second row) Annie McQuade, Millie Lehman, Helen Scott, and Frederick Hoery. The family's first garden was near Smith's Lake, now known as Washington Park; the second was at Harman, near the current Cherry Creek Shopping Center; and the last was created on East Colfax Avenue in 1886. (Courtesy Aurora History Museum.)

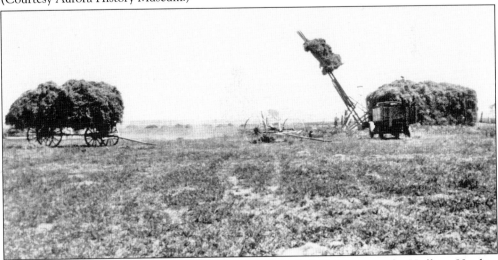

Wagons filled with hay sit waiting for laborers on Max Maul's fields in present-day Hoffman Heights. Farmers began to grow more alfalfa on their land when the price of wheat dipped considerably during the years before World War I. It was a crop that proved to be high in demand as more dairy farms opened in the area. (Courtesy Aurora History Museum.)

Helen E. Hoery (left) married Walter Scott (right) on July 17, 1916, and Scott helped William Hoery with his milking and farming. The Scotts had two girls and named them Helen (center) and Marian (not pictured). Once, while Marian was helping her mother build a rock garden, the two found a fire ring that they thought might have been made by Native Americans. (Courtesy Aurora History Museum.)

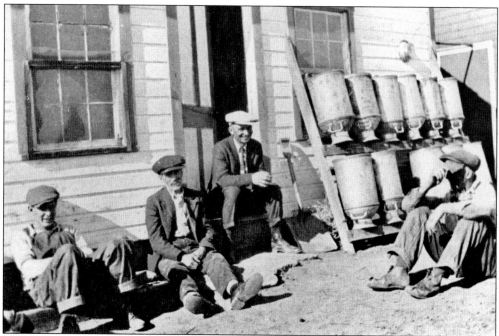

William Hoery opened a dairy store along Sixth and Potomac Avenues called Bill's Milk Depot in 1934. This photograph was taken soon after. He sold dairy goods and produce grown on his farm. Seen here from left to right are Walter Scott, Robert Hoery, Frederick Hoery, and William Hoery. (Courtesy Aurora History Museum.)

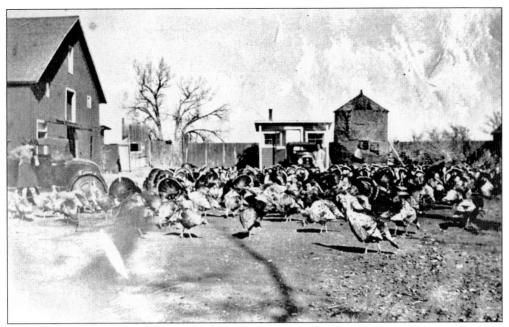

Many people who lived within the city limits had their own gardens and kept their own chickens and cows. Several turkey farms also operated in Aurora. These turkeys belonged to Marian Scott Richards, the daughter of Walter and Helen Scott. (Courtesy Aurora History Museum.)

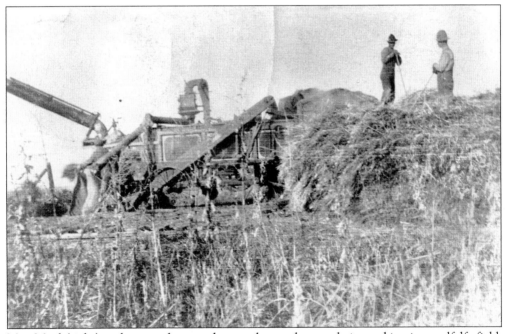

Max Maul (right) and a coworker stand atop a haystack near their combine in an alfalfa field. The Mauls raised sugar beets and alfalfa on the quarter-acre of ground around their home. To the east was land reserved for potatoes and grains, and to the south was the reservoir, fed by a lateral of the High Line Canal to the west. (Courtesy Aurora History Museum.)

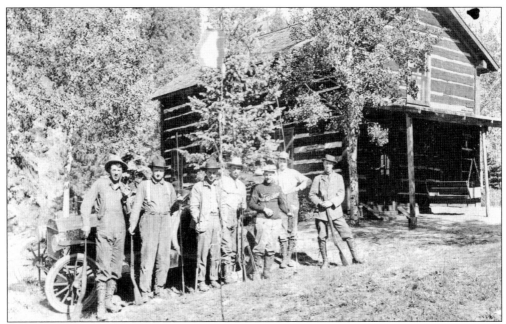

When a hunting party visited Lost Park, Colorado, in 1916, Gerome George and Bill Gaylord came from Maine to promote their tractor called "Little Mule." The party's cabin belonged to the Northern Colorado Irrigation Company. The men pictured are, from left to right, William Hoery, Patrick Kennedy, Walter Scott, Edward Hoery, Everett Judson, unidentified, and Lon Howes. (Courtesy Aurora History Museum.)

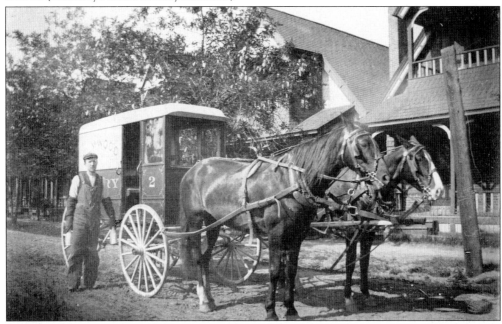

Fred and Irving Purse owned the Purse Brothers Grocery, located at 9708 East Colfax Avenue, which later became Mrs. Louise Purse's Creamery. Fred Purse also operated a dairy farm and sold milk to the community from his milk wagon in 1925. The side of the wagon bears the name "Elmwood Dairy." (Courtesy Aurora History Museum.)

Elizabeth Gully poses outside of her home on Tollgate Ranch. Thomas and Temperance Gully and their seven children emigrated from Tipperary, Ireland, and settled in the mountains of Colorado. They moved to Arapahoe County in 1866. (Courtesy Aurora History Museum.)

This photograph was taken during the September 1924 dedication of Aurora Community Church. Rev. F. E. Smiley raises his hands in prayer over the cornerstone as other members of the congregation sit on the foundation behind him. The building was completed at the corner of East Colfax Avenue and Fulton Street on April 12, 1925. (Courtesy Aurora History Museum.)

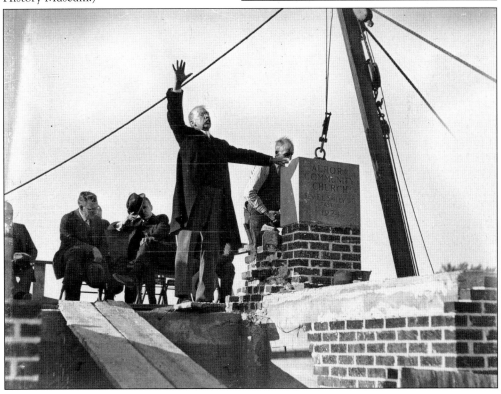

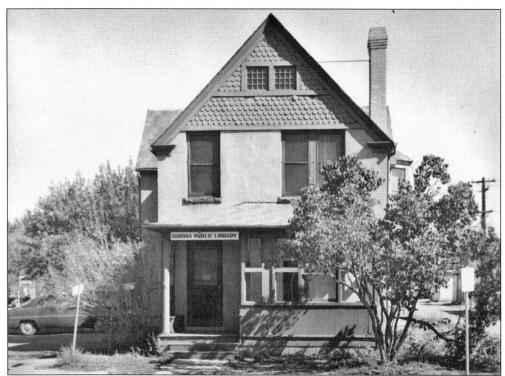

In 1925, several Aurora businesswomen started the Women's Club of Aurora, which is still in existence today. At the time, Aurora had no library system, and these women rose to the task. Together they gathered books, donating many of their own, and helped raise money to fund the first library in 1929. It was located at 1516 Dallas Street in Sarah Wood's house. She was the first librarian, serving the community for 15 years. (Courtesy Aurora History Museum.)

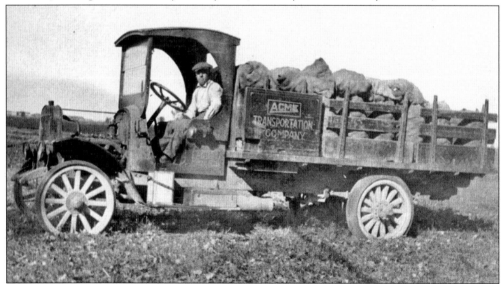

The Mauls grew potatoes at their ranch. Here an unidentified man, probably a family member, hauls spuds in a truck belonging to Shorty Steward. Fitzsimons Hospital is barely visible in the background. (Courtesy Aurora History Museum.)

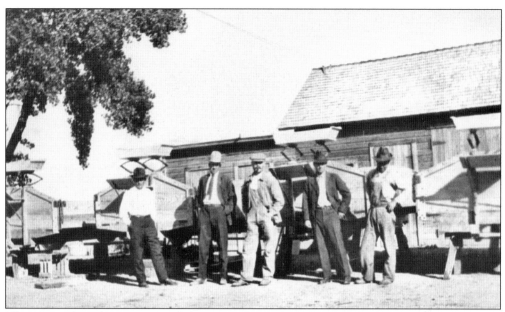

The Hoery farm became one of the top milk-producing and general farms in the area. To keep up with production, 140 cows were maintained. Before he retired in 1943, William Hoery planned out the buildings: two barns for the horses and cattle, a hay loft with a 40-ton capacity, and other structures that stood where the Sable Care Center is today. Shown from left to right are Max Maul Sr., Bill Hoery, John Borck, Edward Hoery, and Bill Falcon. (Courtesy Aurora History Museum.)

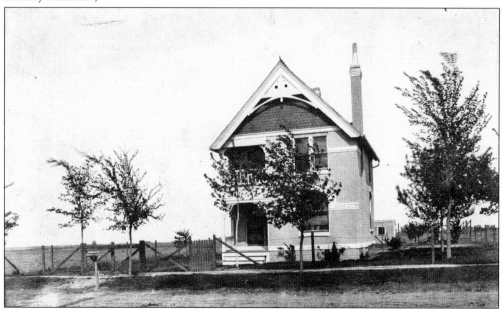

The developers of Fletcher built several Victorian homes that included the latest modern inventions. The houses were considered luxurious because they had indoor bathrooms, water in the kitchen, and hardwood floors. Other features were cherry-wood mantles, oak staircases, coal furnaces in half-basements, and red Castle Rock brick windowsills and doorsills. Some of the houses even sported a porch on both levels. (Courtesy Aurora History Museum.)

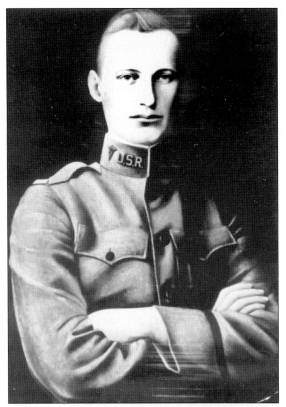

The army made the decision to name U.S. Army Hospital No. 21 after 1st Lt. William T. Fitzsimons. A native of Kansas, Fitzsimons was the first U.S. casualty in World War I. He was a medical officer assigned to the army base hospital in Dannes-Camiers, France, and was killed during an attack on the night of September 4, 1917. (Courtesy Aurora History Museum.)

On April 29, 1918, ground was broken for the first building at U.S. Army Hospital No. 21. By the end of October, wounded men filled the uncompleted wards. Medical officers and supplies were scarce, but the hospital staff did what they could to make the returning soldiers comfortable. (Courtesy Aurora History Museum.)

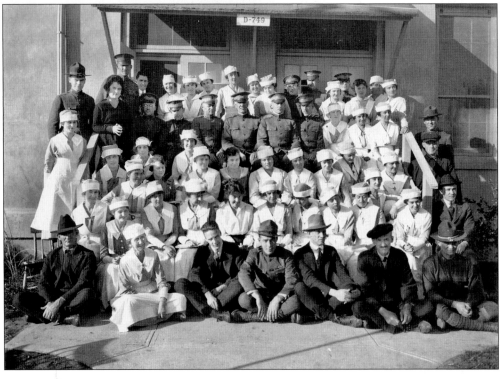

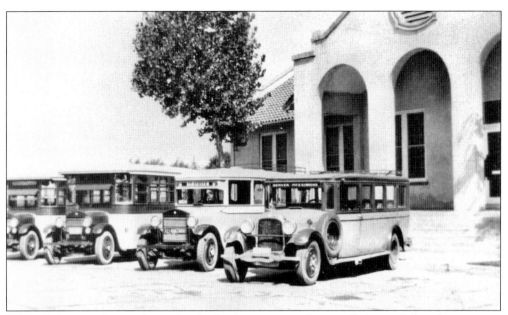

When Fitzsimons Hospital was first built, the access road was still dirt and therefore at times impassable. It was a long walk to Aurora. As a result, a line of jitney buses was formed to transport staff and patients to town. There the trolley could take them to downtown Denver if they wished. (Courtesy Aurora History Museum.)

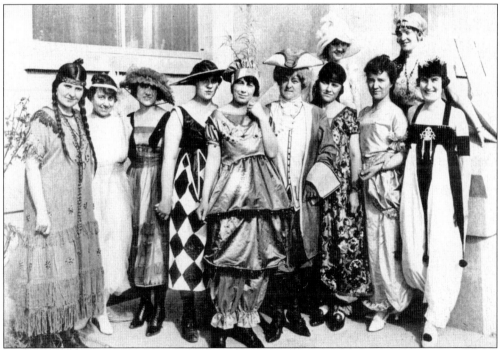

When hospital staff first arrived in 1918, they were greeted with unfinished wooden buildings. Some of the wards were still windowless, and medical supplies were scarce. Yet the nurses at Fitzsimons found time to have fun, as evidenced by their 1920s Halloween costumes. (Courtesy Aurora History Museum.)

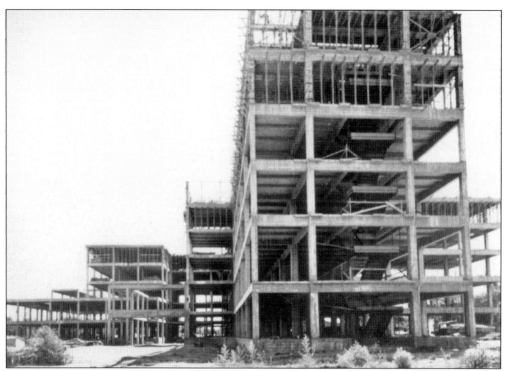

U.S. Army Hospital No. 21 was originally meant to be a temporary resting place for convalescing soldiers. To meet an immediate need, wooden barracks were hastily constructed to greet the first patients in 1918. Following World War I, when succeeding presidents decided to make Fitzsimons a permanent establishment, permanent buildings were needed. Construction was completed on the main building in 1940. (Courtesy Aurora History Museum.)

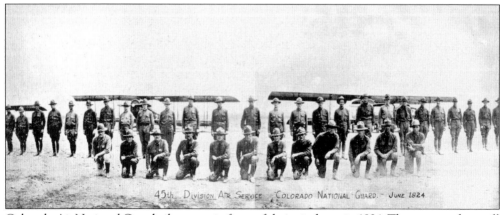

Colorado Air National Guard pilots pose in front of their airplanes in 1924. They operated a small airstrip close to the Agnes Phipps Sanitarium that was later taken over by the War Department in 1938. These men would often take training flights over the fields of Aurora. (Courtesy Aurora History Museum.)

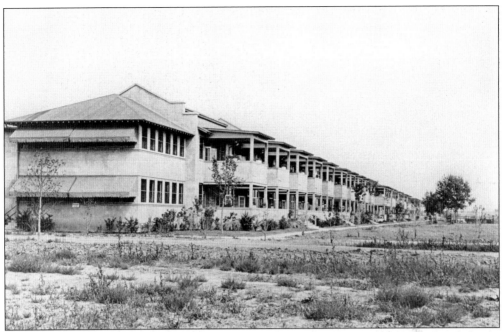

The original infirmary, Building 511, was also sometimes called the Long Building. Intended to be in use for only 12 years, it was used well into the 1980s. It included operating rooms for all of the departments, dental offices, and optical and orthopedic departments, among others. (Courtesy Aurora History Museum.)

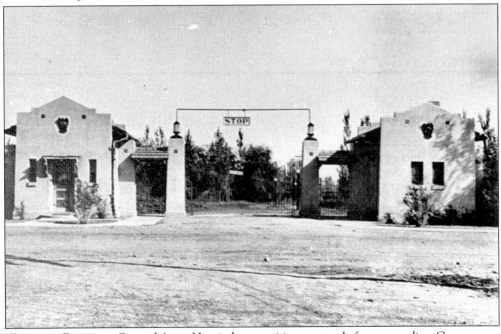

The gate at Fitzsimons General Army Hospital warns visitors to stop before proceeding. Government officials decided that Fitzsimons should become a permanent establishment in 1934. The pictured gate and the guard outpost were built at the corner of Colfax Avenue and Peoria Street. (Courtesy Aurora History Museum.)

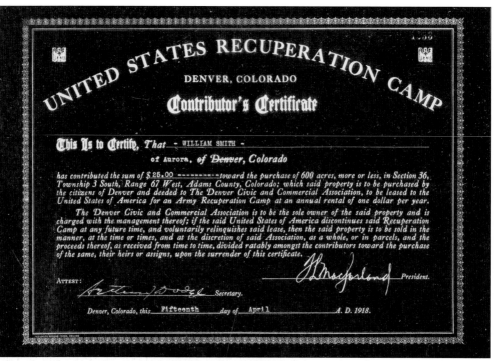

UNITED STATES RECUPERATION CAMP

DENVER, COLORADO

Contributor's Certificate

This Is to Certify, That — WILLIAM SMITH —

of Aurora, of Denver, Colorado

has contributed the sum of $.25.00 -----------toward the purchase of 600 acres, more or less, in Section 36, Township 3 South, Range 67 West, Adams County, Colorado; which said property is to be purchased by the citizens of Denver and deeded to The Denver Civic and Commercial Association, to be leased to the United States of America for an Army Recuperation Camp at an annual rental of one dollar per year.

The Denver Civic and Commercial Association is to be the sole owner of the said property and is charged with the management thereof; if the said United States of America discontinues said Recuperation Camp at any future time, and voluntarily relinquishes said lease, then the said property is to be sold in the manner, at the time or times, and at the discretion of said Association, as a whole, or in parcels, and the proceeds thereof, as received from time to time, divided ratably amongst the contributors toward the purchase of the same, their heirs or assigns, upon the surrender of this certificate.

President.

Attest:

Secretary.

Denver, Colorado, this _Fifteenth_ day of _April_ A. D. 1918.

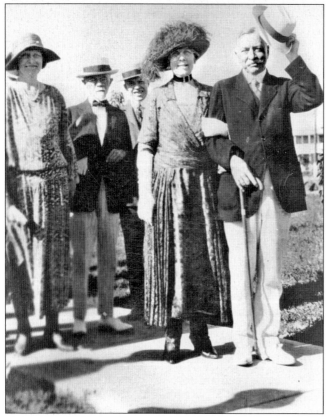

The Denver Chamber of Commerce and others persuaded the army to construct a hospital in the area. Because of its close proximity, Aurorans were involved with the project from the beginning. Judge Gutheil offered his property for sale, and many citizens purchased bonds to fund the sale of the land to the City of Denver. Here is a copy of a bond purchased by William Smith. (Courtesy Aurora History Museum.)

Fitzsimons has been visited by several presidents throughout the years. The first was Pres. William G. Harding (right), who came to view the grounds with his wife, Florence, in June 1923. Colorado senator Lawrence Phipps stands second from the left. (Courtesy Aurora History Museum.)

Francis Brown Lowry was born in Denver on December 1, 1894, and graduated from Ann Arbor University in 1917. Assigned to the 91st Aero Squadron, he was shot down by German aircraft fire on September 26, 1918. He was buried in Argonne Cemetery in Romagne, France; however, in 1921, his remains were transferred to Fairmount Cemetery, adjacent to the land that would become Lowry Field. (Courtesy Aurora History Museum.)

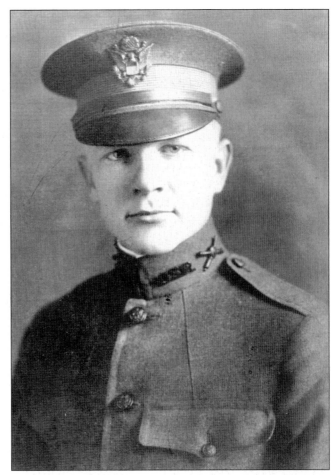

William Smith, the so-called "father of Aurora's public schools," was involved with the organization of Aurora Public School District No. 28 and served as secretary of the school board for a record-breaking 50 years, from April 1885 to 1935. The William Smith High School was named for him in 1931. It was one of Aurora's first high schools. (Courtesy Aurora History Museum.)

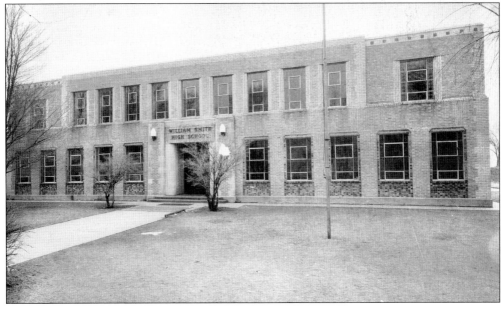

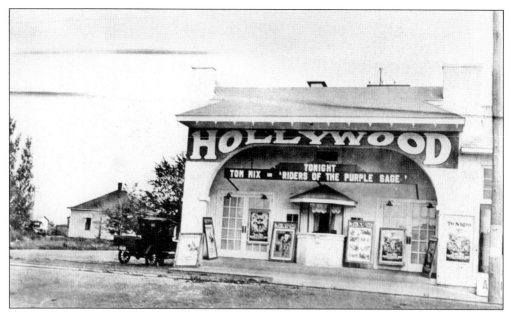

Aurora's first successful movie theater, the Hollywood, opened in 1925. Previously residents had to take the train to Denver to see a film. The theater did not fair well and was eventually closed because it could not get movies until they had experienced a full run in Denver. By the time movies reached the Hollywood, everyone had already seen them. (Courtesy Aurora History Museum.)

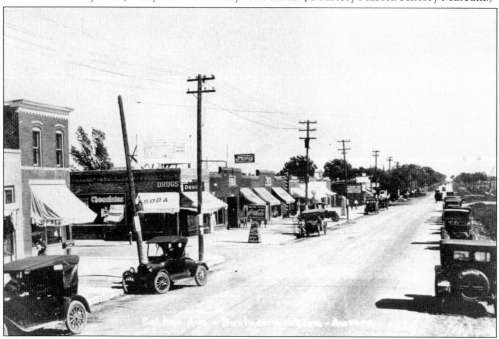

Arapahoe County Road No. 54 was later named Colfax Avenue after Schuyler Colfax, an Indiana congressman who later served as vice-president. It is not quite known how his name ended up on a main street out West, but he visited relatives in the Denver area three times in the late 1800s. This view of East Colfax Avenue was taken in 1924, when it became part of U.S. Highway 40, the first completed east-to-west national highway. (Courtesy Aurora History Museum.)

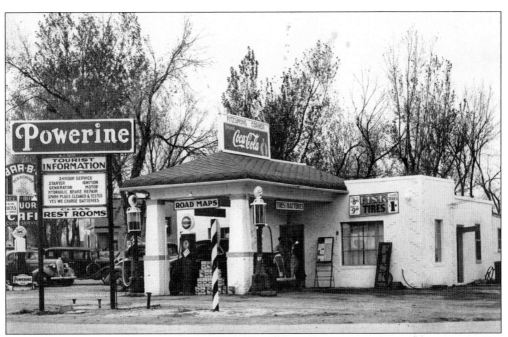

This Powerine station served tourists and locals alike on Colfax Avenue. It was one of the first businesses to greet travelers on their way toward Denver from the east in the 1930s. Colfax Avenue later became part of U.S. Highway 40, making Denver and Aurora more accessible to tourists. (Courtesy Aurora History Museum.)

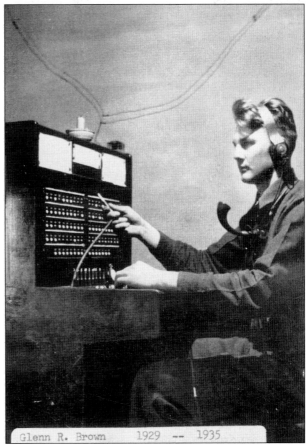

Glenn R. Brown 1929 -- 1935

Aurora's first telephone exchange began operations in 1910. An early advertisement for businesses in Aurora reveals that several of them had phone numbers that were only three to four digits long. In 1928, a new exchange opened at Colfax Avenue and Dayton Street. Glen R. Brown was the Aurora switchboard operator from 1929 to 1935. The town switched to dial phones in 1955. (Courtesy Aurora History Museum.)

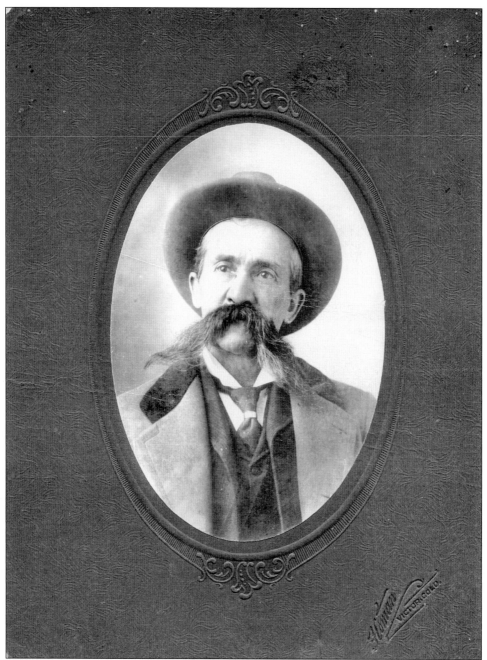

Alfred Gaines Stitt was Aurora's most colorful law enforcement officer, serving as town marshal and water commissioner during the early part of the 20th century. He was beloved by both adults and children, who called him "Dad" or "Pop." The *Aurora Democrat-News* published the following about Stitt in 1909: "It is with pleasure that we write these few lines to publicly thank our marshal for the splendid service he is giving the town of Aurora. After that terrible storm he was busy at sunup and had a path through the snow on every street by 9 a.m. He has also constructed a skating rink for the young folks where all danger is eliminated and the fun is just as great. Aurora is to be congratulated for having such an officer." (Courtesy Juanita Sparks.)

Three

HARD TIMES

October 29, 1929: the worst crash in Wall Street history occurred when over 16 million shares were traded and averages fell nearly 40 points. Shock reverberated through the country. Unemployment skyrocketed, and by 1932, more than 10 million people had lost their jobs. Bread lines grew longer and more banks failed as the decade of the 1930s wore on. The nation's banking structure seemed to be on the verge of utter collapse.

As Franklin D. Roosevelt became president in 1933, he immediately began to take measures to alleviate the national crisis. He called for a bank holiday, repealed the Prohibition Act, and appropriated money to be used for relief, to create work for the unemployed, and to save homes and farms from foreclosure.

In 1927, Aurora's only bank suffered its first robbery. The *Democrat-News* reported, "What proved to be the most hectic five minutes that Aurora ever lived through occurred Monday afternoon about 2 o'clock, when four armed bandits attempted to rob the First National Bank." Shots were fired, leaving six people wounded; two men died from their wounds. However, this was not the end of the bank's troubles. Federal investigators discovered that the bank was insolvent and ordered it into receivership. In spite of that, local businessmen and women were later successful in reorganizing the bank.

While this was going on, farmers in Colorado were experiencing difficulties they had never faced before on such a large scale. In the early years of the 1900s, dryland farming was a common technique in turning the semi-arid lands of the plains into productive farms. A combination of wartime high prices and increasing availability of farming machinery helped encourage farmers to plow up their lands and plant crops. Grass covering the land was plowed under or trampled underfoot by cattle, leaving the topsoil bare and vulnerable to high winds. Farmers in the West watched in dismay as prairie winds carried their topsoil away, darkening the sky with dust.

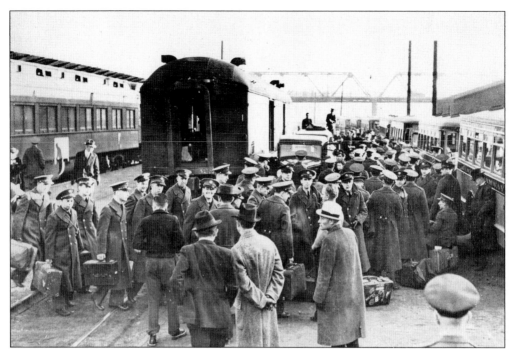

Aurora's first cadre of 300 students bound for the Air Corps Technical School detrains in Denver on February 12, 1938. They have just arrived from Chanute Field. Accompanying them are 30 freight cars loaded with equipment for the school. (Courtesy Aurora History Museum.)

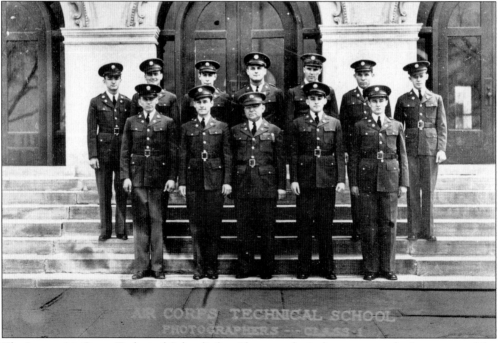

The Lowry Air Corps Technical School's first Photography 1 class poses on the front steps of the former sanitarium on April 13, 1938. The school primarily taught photography and observation, while the air strip was used for training flights. (Courtesy Aurora History Museum.)

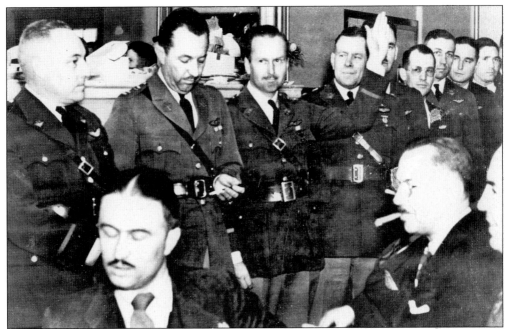

On February 26, 1938, the chamber of commerce hosted a luncheon to welcome military officers arriving for the Air Corps Technical School. Here the officers are being introduced. Shown from left to right are Maj. Clarence Wilson, Capt. John Nissly, Capt. Donald Norward, Maj. Alfred Jewett, 1st Lt. Norman H. Ives, 1st Lt. Charles Leitner, 1st Lt. Jerald McCoy, 2nd Lt. Monty Wilson, and Capt. Harold Lee. The gentlemen in the foreground are unidentified. (Courtesy Aurora History Museum.)

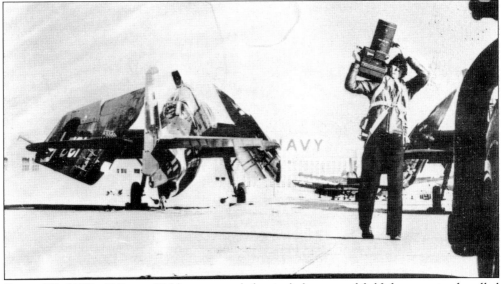

During World War II, Lowry Field was expanded to include a second field that was simply called Lowry Field II. After hostilities ceased, the second field was renamed Buckley Field in honor of 1st Lt. John Harold Buckley of Longmont, Colorado. He was shot down on a strafing mission behind German lines during the Argonne offensive in World War I. He had been a member of the Colorado National Guard. (Courtesy Aurora History Museum.)

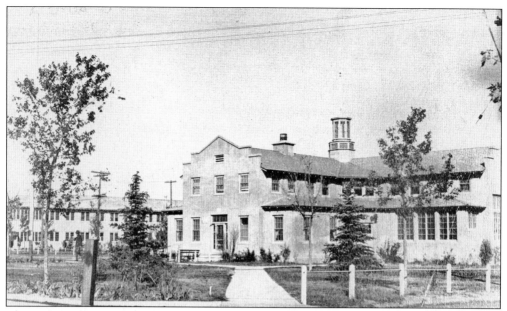

The Red Cross building at the Fitzsimons General Army Hospital was built in the shape of a cross at the center of the grounds. It functioned as a center for many essential non-medical activities as well. In an effort to boost patients' morale, several recreation attractions were offered, including plays, music, boxing matches, and games. (Courtesy Aurora History Museum.)

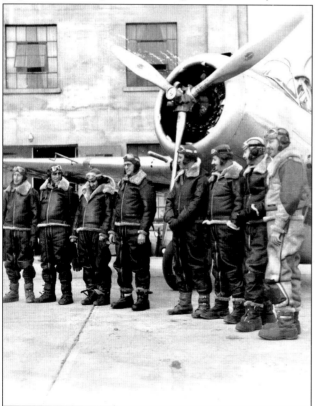

Officers of the Colorado Air National Guard gather in front of their airplane in the 1930s, when they were using Lowry Field for training flights. These men were part of the 120th Observation Squadron, a volunteer unit organized in 1923. (Courtesy Denver Public Library, Western History Department.)

Patients and staff still found time to have fun at the Fitzsimons General Hospital. The Red Cross building was used for community events such as theatrical productions, games, literary productions, parties, and as in this case, a Valentines Day dance in the early 1950s. (Courtesy U.S. Army.)

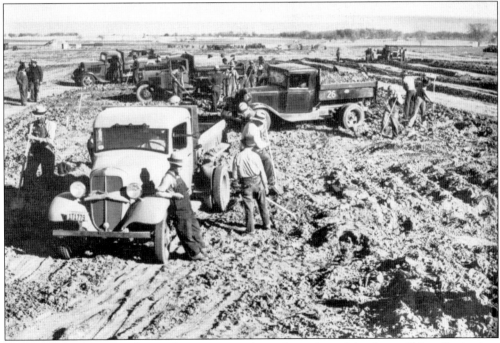

The War Department took over the tiny national guard airstrip and the Agnes Phipps Sanitarium in 1938. Construction began immediately on a new, enlarged runway. One source states that monies from the WPA helped fund the building. (Courtesy Aurora History Museum.)

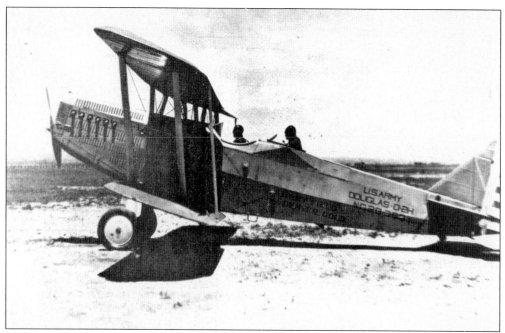

This Douglas 08 was used during the 1920s as a training plane for the Colorado National Guard. The pilots would fly over the fields around Aurora on training missions, practicing their observation skills and taking aerial photographs. (Courtesy Aurora History Museum.)

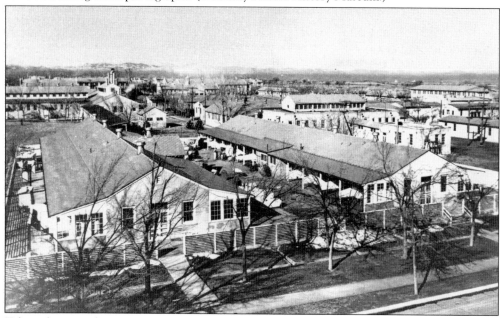

Tuberculosis was the primary concern of Fitzsimons Hospital since its inception. The Heliotherapy Ward (sun treatment) was introduced by Col. Earl H. Bruns, who had suffered from the disease himself at one time. He studied in Leysin, Switzerland, under Dr. Rollier, a Swiss surgeon. Patients would spend many hours under the sun while lying on screened platforms that protected them from the wind. The treatment was innovative, and it was later learned that tuberculosis was especially responsive to the rays of the sun. (Courtesy Aurora History Museum.)

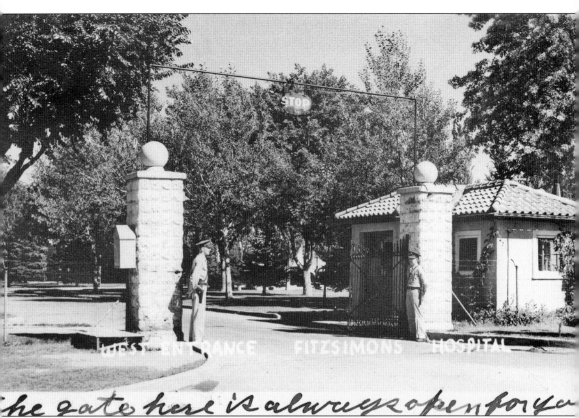

This wartime photograph depicts the west entrance of Fitzsimons around 1942. The Red Cross building was located just inside this gate, the paved road ending in front of it. Two guards and the guardhouse are visible beside the two pillars on each side of the gate. This photogram was on a postcard. The inscription, "The gate here is always open for you," was written by one of the nurses to a former patient. (Courtesy Aurora History Museum.)

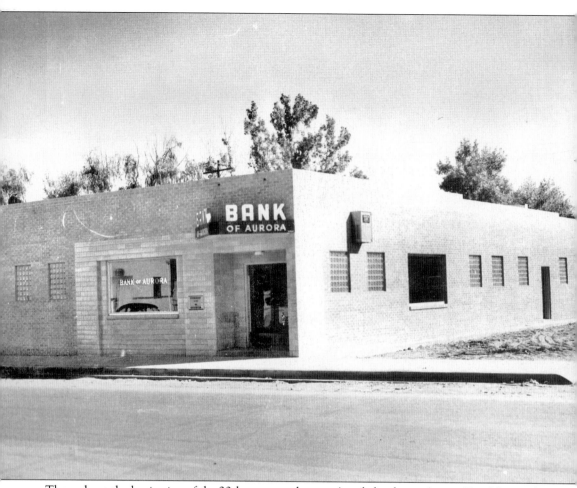

Throughout the beginning of the 20th century, the town's only bank was Aurora First National. Bank president T. F. Gilligan was well liked among Aurorans until later years, when the bank was forced to close and ordered into receivership in the 1930s. The Bank of Aurora was then formed in 1943 by C. R. Campbell and A. W. Hamilton. It moved to a building at 1543 Dayton Street in October 1950. (Courtesy Aurora History Museum.)

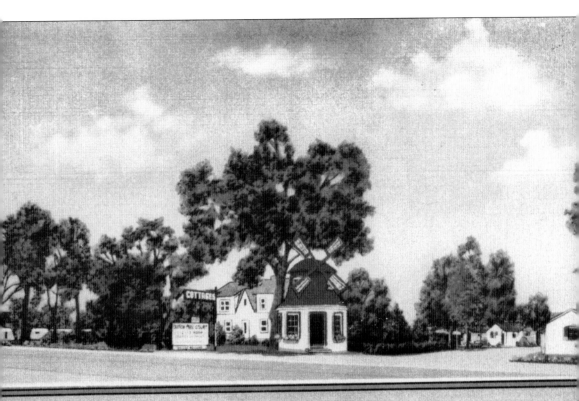

DUTCH MILL
COTTAGE COURT

HIGHWAYS 36 - 40 - 287, EAST ENTRANCE TO DENVER, CO[

11937 EAST COLFAX AT FITZSIMMONS HOSPITAL CORNER

5 Acres of Lawn, Trees and Shrubs. Modern Trailer Accommod

The Dutch Mill Cottage was built in the 1930s by Col. Arthur L. Hart, who had contracted tuberculosis in France during the war. The property was located at 11937 East Colfax Avenue and includes five acres of lawns, trees, and shrubs. This 1941 postcard advertises modern cottages and modern trailer accommodations. The blue and white Dutch Mill has since become a historic landmark. (Courtesy Aurora History Museum.)

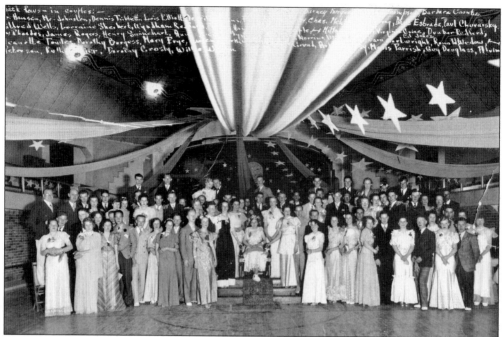

Prom night in 1927 was quite an affair for Aurora's only high school, which would be renamed in honor of William Smith a few years after this photograph was taken. The large assembly room was elegantly decorated for the dance. The building still stands, located at 10100 East Thirteenth Avenue. (Courtesy Aurora History Museum.)

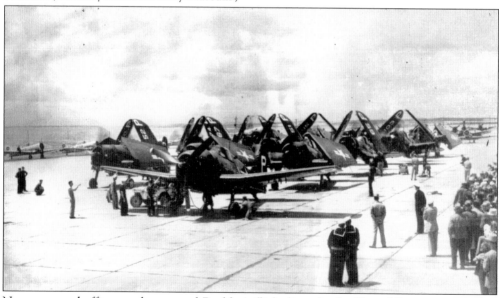

Navy men and officers gather around Buckley's flight line. As the United States increased its involvement in World War II, plans were made to enlarge the Lowry Army Air Field. Airplanes were now an important part of warfare, and the need for a larger training field was apparent. Construction of Buckley Field began in 1942. The Army Air Corps Technical School, offering B-17 and B-24 bombardier and armor training, was opened on July 1 with Brig. Gen. L. A. Lawson commanding. (Courtesy Aurora History Museum.)

56

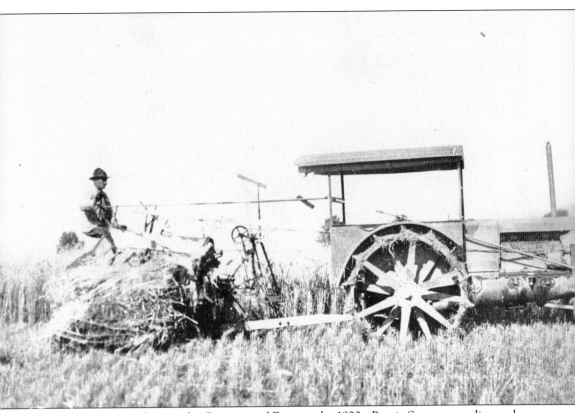

Max Maul harvests wheat at the Cottonwood Farm in the 1920s. Peoria Street was a dirt road at the time, and it was Maul's job to keep it open in bad weather. The soil in that area was a heavy clay that would frequently clog his tires. (Courtesy Aurora History Museum.)

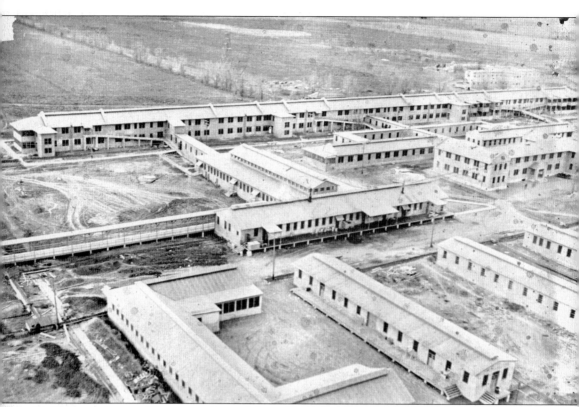

This aerial view of Fitzsimons General Army Hospital shows the quartermaster area. The paved road ended at Monaco Boulevard, so Montview Boulevard was a sea of mud after any rain or snow. Montview was the main access road for receiving supplies from Denver. (Courtesy Aurora History Museum.)

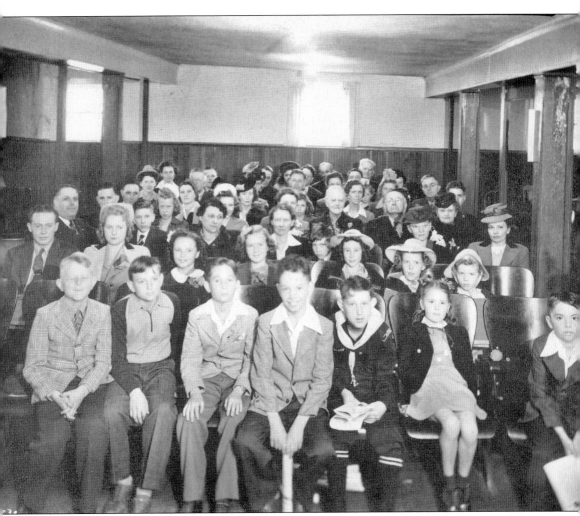

Children and adults pose for a photograph on Easter Sunday in 1941 in the basement of the church started by Rev. Marion Brown. Pictured from left to right are the following: (first row) all unidentified; (second row) Clayton Wells, Stewart Parmalee, Richard Stoner, ? Hamilton, ? Fernwells, Jean Bowser, Mary Alice Kelley; (third row) Rev. Marion Brown, David Brown, Veva Gordon, Dorothy Brown, Bobby Brown, Mrs. Connors, and Mildred Stoner; (fourth row) Bill Loback, Jane Kathrens, two unidentified people, Emma Cook, Green Blosser, and Frances Hawkins; (fifth row) two unidentified people, Lovey Horton, possibly Reverend Brown's daughter, Florence Haught, and Robert Haught; (sixth row) Mary Judlin, Fred Kathrens, Mellie Kelley, Heman Kelley, Mrs. Howard Wells, and Howard Wells; (seventh row) all unidentified. (Courtesy Aurora History Museum.)

The Gully family hosted an annual rodeo near Tollgate Creek from the 1920s to the 1950s. Townsfolk would turn out every summer for the popular event. John Gully, the youngest son of Thomas Gully, was known for the draft horses he raised and sold to Denver businesses for use in pulling delivery wagons. (Courtesy Aurora History Museum.)

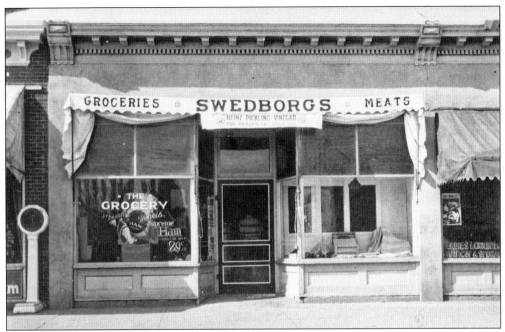

The Swedborgs moved into the area and opened a store at 9637 East Colfax Avenue, shown here in 1935. Note the sign in the window advertising supreme ham for 29¢ a pound. (Courtesy Aurora History Museum.)

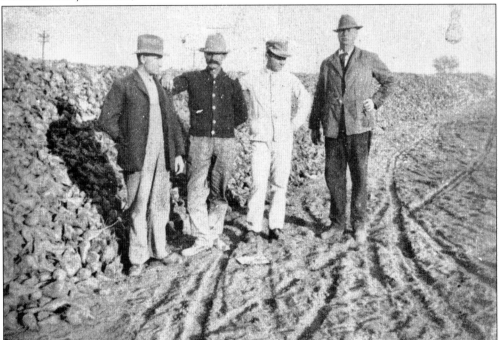

Local businessmen pause for their photograph to be taken while overseeing the sugar beet dump in Aurora in the early 1930s. The men have only been identified by their surnames. Seen from left to right are Snyder, Talcott, Goodsel, and Chambers. To their left is a pile of sugar beets that has not been processed. (Courtesy Aurora History Museum.)

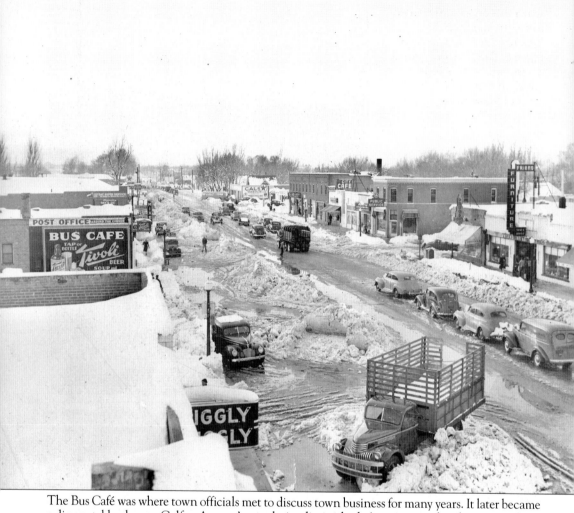

The Bus Café was where town officials met to discuss town business for many years. It later became a disreputable place as Colfax Avenue's popularity diminished. A snowstorm hit the metropolitan area in 1946, during which it snowed 33 inches in three days. This view of Colfax Avenue looks to the northwest. (Courtesy Aurora History Museum.)

After the flood of 1939, when this bridge was washed away, the city took the opportunity to straighten the curve and replace the span at Sixth Avenue and Tollgate Creek. (Courtesy Aurora History Museum.)

Aurora used to have several lakes and ponds within its city limits. Located near the Hoery farm, this lake was used for swimming. The people shown splashing in the pool are identified only as Robert (front, left), Mary (front, right), Alice (back, left), and Lin. The small lake has since been filled and is now part of Morris Heights. (Courtesy Aurora History Museum.)

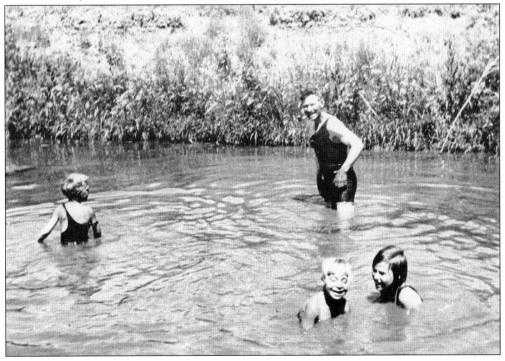

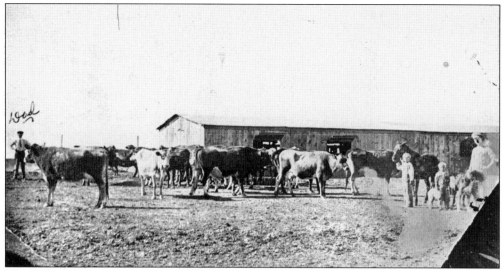

The Parker family began a dairy at what is now the corner of Twenty-Third and Galena Streets and later relocated it to Geneva Street. This photograph shows the Parkers' milk cows in front of their outbuildings, along with some unidentified children. Though they found the dairy business to be quite profitable, the family left the area in 1930. (Courtesy Aurora History Museum.)

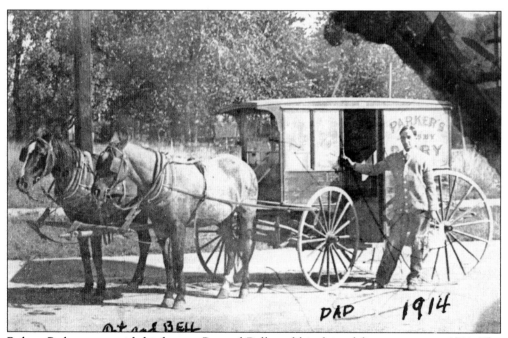

Robert Parker poses with his horses, Pet and Bell, and his dairy delivery wagon in 1914. The Parkers milked 60 cows daily, selling milk for 9¢ a quart and butter for 30¢ a pound. Robert also briefly served on the Aurora City Council. (Courtesy Aurora History Museum.)

Four

BOOM

Following World War II, Aurora once again experienced a boom. Developers swarmed the empty lots still within the city limits and began to build. Other developments began rising up to the east as well. One of the most notable of these was Hoffman Heights, the modest brick homes being built where Max Maul had farmed for many years.

Samuel Hoffman was not highly regarded by other builders in the area because he had created a way to build homes with more features at lower prices. He was also the highest-paying contractor in the area. Instead of hiring specialists, he would hire union laborers and apprentices and train them for one specific job. He would have two bricklayers work together; while one constructed the corner of the brick wall, the other toiled on the side wall. When they finished, they would move on to the next house, and so on. The houses were erected in record time.

Hoffman arranged to have water and sewer lines brought out from Denver to his new housing development for $195,000. He built his own systems, since Aurora was not interested in extending pipes to the houses that were rising up on the plains to the east.

Within three years, all the houses had been completed, and a total of 7,000 people lived in the brick homes—a number equal to roughly one-fourth of Aurora's total population at the time. The development boasted its own shopping center, built for its residents' convenience, although it was several months before any telephone service was installed.

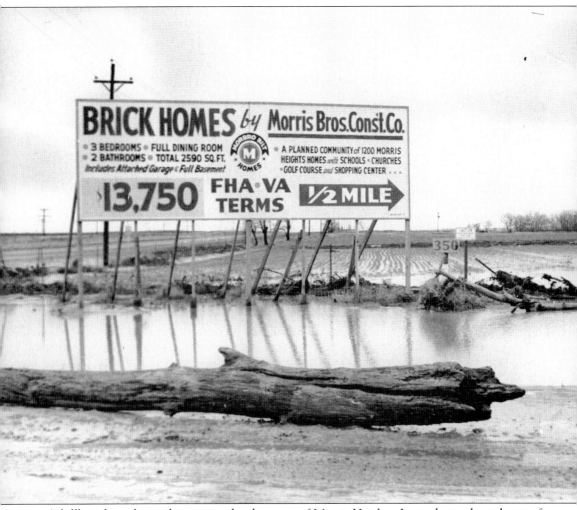

A billboard proclaims the coming development of Morris Heights. It was located northeast of Fitzsimons. The Morris Brothers Construction Company developed the area, advertising a ready-made community complete with schools, churches, and a golf course. The city later adopted an amendment banning any large billboards or signs within city limits. (Courtesy Aurora History Museum.)

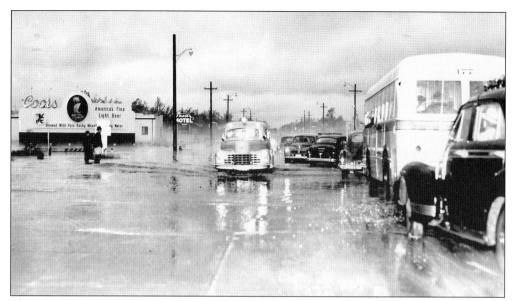

This 1965 photograph shows Colfax Avenue flooded after a severe rainstorm. The vehicle on the left is an ambulance making its way through the water to Fitzsimons General Army Hospital. Aurora's dry, baked earth became a nightmare during rain spells. Every few years, the creeks would swell with rainwater and snowmelt, causing floods throughout the city. In later years, steps were taken to prevent the recurring floods, including the installation of several drain boxes. (Courtesy Aurora History Museum.)

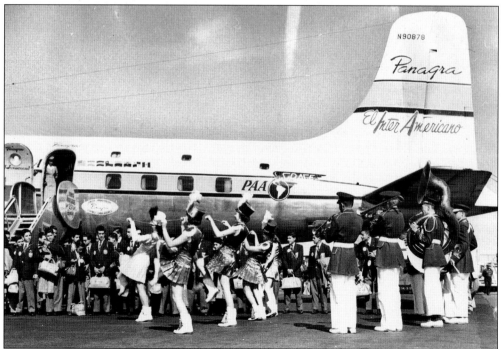

At the Stapleton Airport, the high school band and cheerleaders greet students arriving for the Lowry Technical Training Center. High school bands were commonly used for special events, celebrations, and parades in the city for several years. (Courtesy Aurora History Museum.)

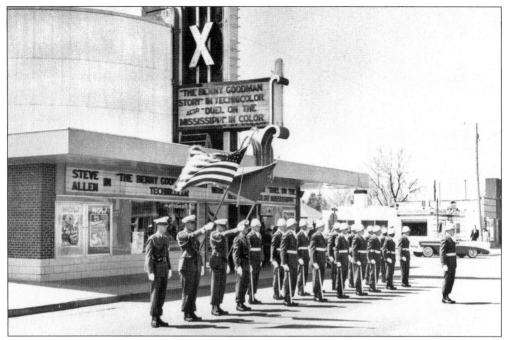

The Fox Theatre was a popular starting point for the many parades that Aurora townsfolk enjoyed. Here a military color guard is assembled and ready to start marching down Colfax Avenue. (Courtesy Aurora History Museum.)

A class from the Coal Creek School poses for a portrait in the 1960s. Pictured from left to right are the following: (first row) Milton Smith, Dorothy Smith, Raymond Smith, and Marvin Smith; (second row) Virginia Smith, Juanita Mays, Donald Smith, and Clifford Mays. (Courtesy Aurora History Museum.)

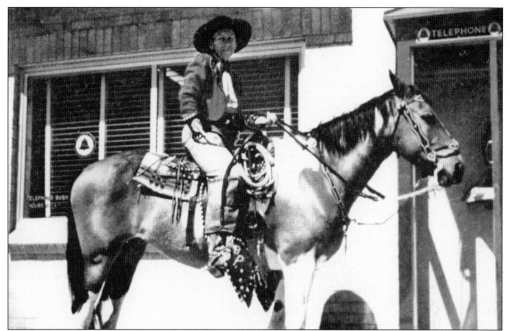

Billie Preston was a favorite among children in Aurora for many years. In the 1940s and 1950s, she would ride her horse Patches up and down the streets of the community. Here she is shown astride Patches in front of the telephone office on Colfax Avenue. (Courtesy Aurora History Museum.)

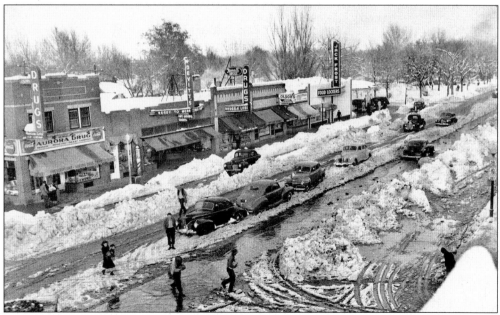

Citizens step carefully as cars inch through the slush in this 1946 photograph. The snapshot shows the north side of the 9700 block of Colfax Avenue. Jack Frost Lockers, the building on the right, was a place where residents could rent a locker to keep frozen meat. One local remembers being sent down to get some meat for dinner on several occasions when she was a little girl. The store also offered to freeze game for hunters. (Courtesy Aurora History Museum.)

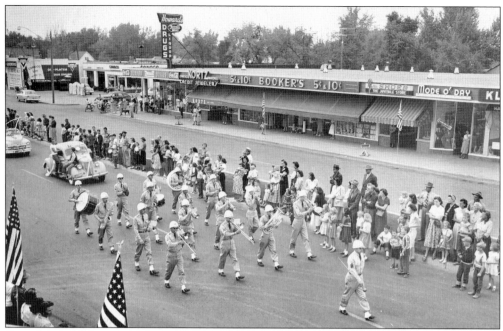

One of Aurora's favorite traditions for several years was to host the Gateway to the Rockies Parade, which would travel under its namesake sign. Everyone turned out for the event. In the 1950s, Miss Aurora would ride in a special car while entrepreneurs would hire buses or cars to display signs advertising their stores and wares. (Courtesy Aurora History Museum.)

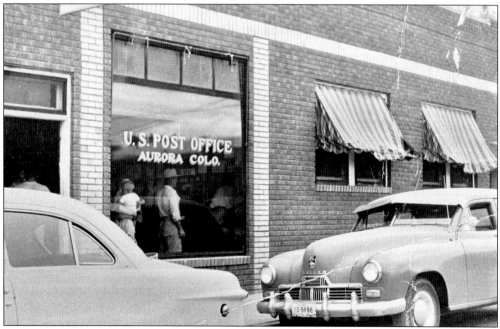

Aurora's first post office was a tiny cubicle in Gresham Jones's general store. On July 30, 1928, a new post office opened on Colfax Avenue with Frank Shedd as postmaster. The office was later relocated to Sixteenth Avenue and Elmira Street, shown here in the 1950s. (Courtesy Aurora History Museum.)

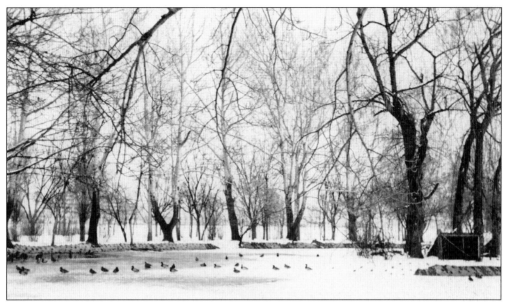

The smallest wildfowl preserve in the country was established in Fitzsimons in 1927 by Col. Paul C. Hutton after he was given some mallard ducks. The preserve's one acre was obscured by trees and shrubs, so few people were aware of its existence. The pond, remaining from Gutheil's Park and Nursery, was kept stocked with trout and was a favorite haunt of President Eisenhower when he was hospitalized at Fitzsimons. It was also called the General's Pond. (Courtesy Aurora History Museum.)

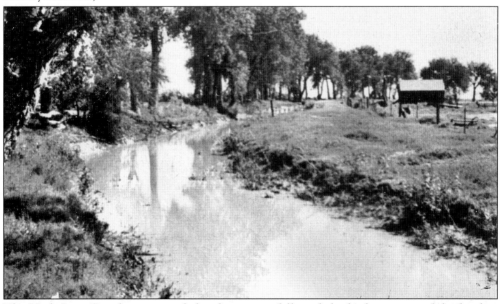

The High Line Canal was named thus because it followed the high contour of the land in order to get the water to travel as far as possible. Chief engineer Edwin S. Nettleton designed the canal. It was gravity fed, dropping about two feet in elevation for each mile in length, and was 71 miles long, 7 to 4.5 feet deep, and 20 to 40 feet wide. It was completed in 1883 at a cost of $650,000. In this photograph, one of William Smith's outbuildings is to the right. (Courtesy Aurora History Museum.)

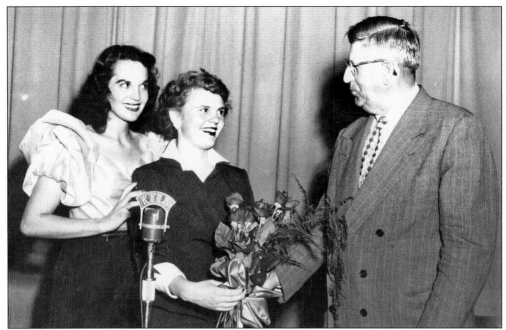

During the 1950s and 1960s, the Miss Aurora Pageant was held at the new Fox Theatre on Colfax Avenue. Here Mayor Chester Tupps stands with Miss Aurora (left) and an unidentified contestant. Jo London won the title this year and went on to win the Miss Colorado title in 1951. (Courtesy Aurora History Museum.)

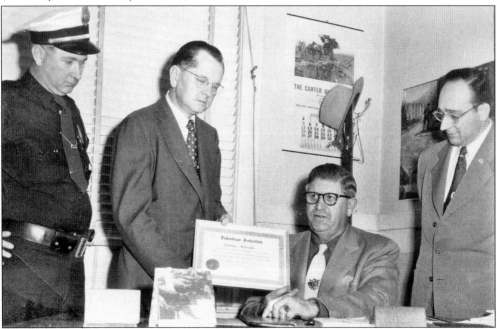

Mayor Tupps sits at his desk in the old city hall while police chief Spencer Garrett stands to the left. The unidentified man next to Garrett is presenting the mayor with an award for no pedestrian fatalities in 1952. The man standing to the right is an unidentified local insurance salesman. (Courtesy Aurora History Museum.)

First Lady Mamie Doud Eisenhower had relatives in Denver, and during the summers of the 1950s, the Eisenhowers visited the city. The president conducted business at the Lowry Base, thereby centering the attention of the nation on Aurora during those months. Newspapers called it President Eisenhower's "summer White House." (Courtesy Aurora History Museum.)

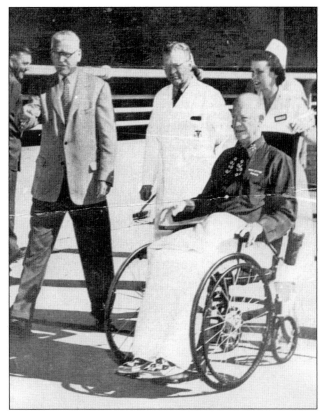

President Eisenhower suffered a heart attack while visiting Denver in the summer of 1955. He was brought to Fitzsimons Army Hospital, where the well-trained staff nursed him back to health. Here he is shown on the sun deck, where he would go every day in the afternoon to view the well-wishers. (Courtesy Aurora History Museum.)

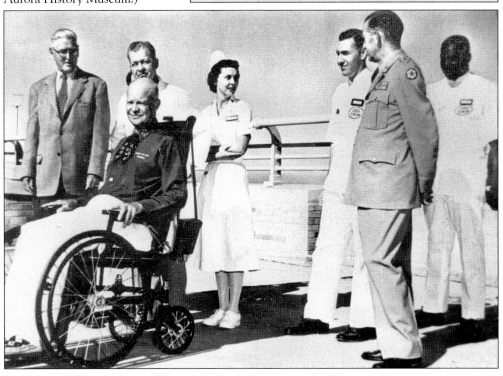

A young Robert Hoery is pictured with his pony, named Trixie. In the town's earlier years, one of the main problems was animals running at large. Most of the land was still undeveloped, and as a result, cattle, horses, and sheep were continually straying from their pastures. An ordinance was passed to build a pound to house the offending animals. Citizens kept animals in the city limits as late as the 1950s. (Courtesy Aurora History Museum.)

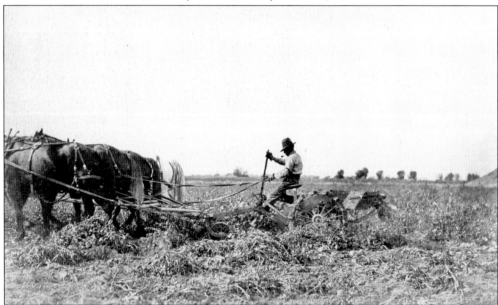

Max Maul works during harvest time. The Mauls lived in a house that was located about where Eleventh Avenue and Quentin Street are now. The outbuildings, including a smokehouse and a barn big enough for 20 cows, were later razed by Samuel Hoffman as he constructed his development. (Courtesy Aurora History Museum.)

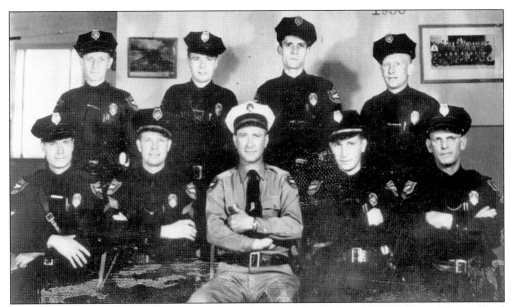

In 1949, there was only one policeman and police car for a population of 11,000. Mayor Tupps offered Spencer Garrett the job of police chief and asked him to organize a modern force. Garrett (third from left, front row) replied, "Only if I receive no interference from the city council whatsoever." By 1955, Garrett had done what he promised. He had a force of 19 academy-trained officers and five cars. (Courtesy Aurora History Museum.)

Shown from left to right, Ruth Fountain, Eleanor Foley, and an unidentified woman gather around Mayor Paul Beck while he signs a document in the 1960s. Fountain was heavily involved with city politics throughout the years, serving on the city council and on various committees, such as the Explore Commercial Opportunities group. She is the current president of the Aurora Historical Society. (Courtesy Aurora History Museum.)

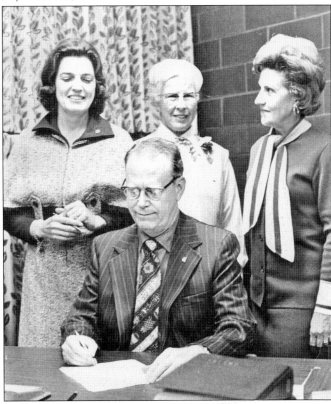

In the 1950s, Aurora became a one-horse town. Neighbors had complained about Billie Preston's animal, and at first town officials ruled that no horse could be kept within the city limits. But Preston kept her horse. Patches became the only horse that could be ridden on Aurora Streets. In 1957, a judge ruled that the horse had precedence over any moving vehicle. (Courtesy Aurora History Museum.)

When Sam Hoffman built his brick houses, he also included a shopping center for the residents. Busley's Grocery was one of the largest stores in this complex, called Hoffman Heights Shopping Center. (Courtesy Aurora History Museum.)

Aurora's junior-league baseball team is pictured in the 1950s. Baseball has been one of the favorite sports since Aurora's beginning as the town of Fletcher. The Arapaho Little League was founded in 1972 and has been a major influence in local games ever since. (Courtesy Aurora History Museum.)

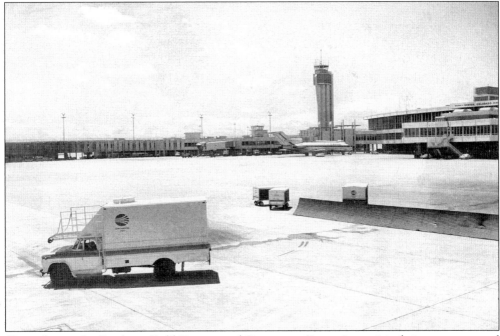

Shown here is the Stapleton Field Continental Concourse. Denver's municipal airport was named after one of its mayors, Benjamin Stapleton, who was instrumental in the opening of Denver's first aerodrome in 1929. Tensions rose when Denver proposed to extend a runway into the city of Aurora. (Courtesy Aurora History Museum.)

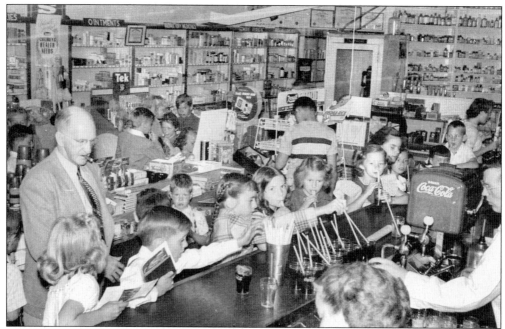

Residents remember going to Bert Howard's drugstore when they were children. Howard, seen here in the 1960s, would give youngsters free colas for going to church if they could show him their Sunday school papers. (Courtesy Aurora History Museum.)

Mayor Norma Walker is pictured with fire department officials. Shown from left to right are Chief William Hawkins, unidentified, Walker, and Robert Wright. Aurora's fire department operated on a volunteer basis in its early years, but in 1955, it was reorganized as a full-time force with William Hawkins as chief. The force, consisting of 12 firemen and two pieces of equipment, was responsible for six square miles. By 1975, the department included 138 men in 11 companies. (Courtesy Aurora History Museum.)

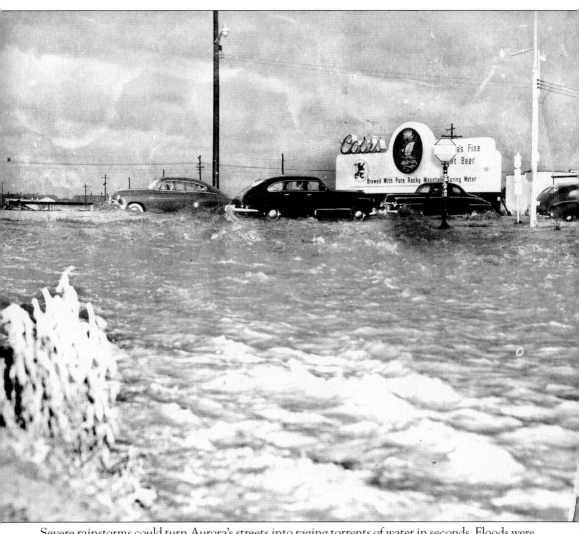

Severe rainstorms could turn Aurora's streets into raging torrents of water in seconds. Floods were common occurrences until drainage boxes were installed. The dry climate would cause moisture to puddle on the surface of the ground. (Courtesy Aurora History Museum.)

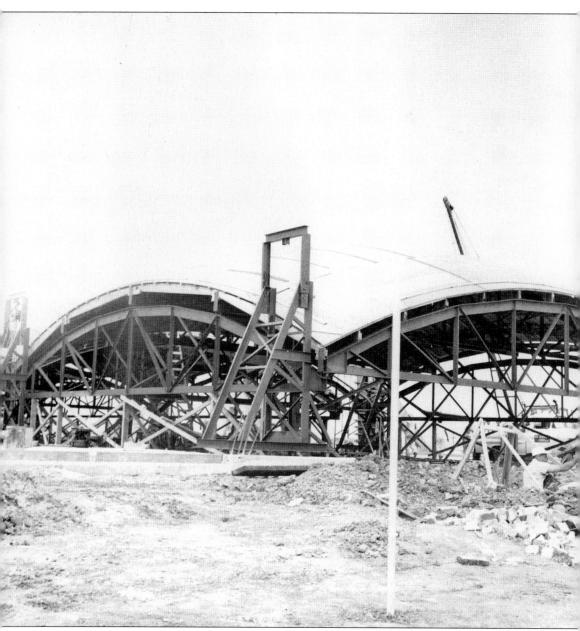

Fan Fare, now an empty building sitting on Havana Street, used to be Aurora's largest department store. It was a place where one could purchase anything from house wares to clothing and other miscellaneous items. (Courtesy Aurora History Museum.)

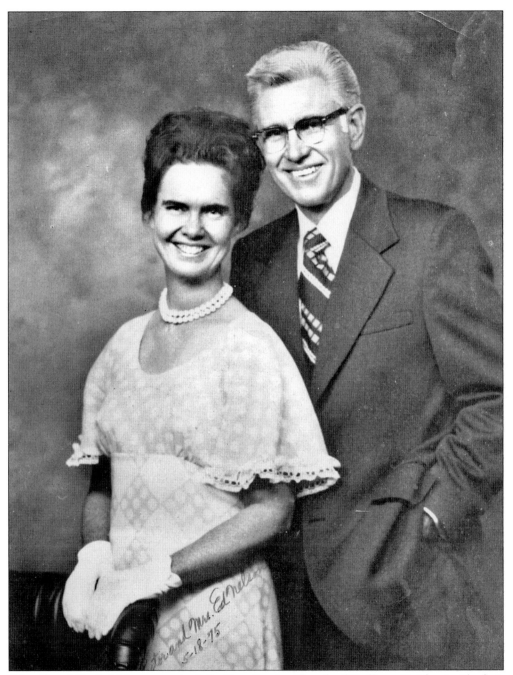

Edward and Guyla Nelson organized the First Baptist Church of Hoffman Heights inside their home at 954 Quari Street in 1954. Edward knocked on every door in the community, inviting residents to his services. As membership grew, services moved into the garage. The Nelsons went on to build another church on the other side of town in later years. This photograph was taken on May 13, 1975. (Courtesy Gail Newcomb.)

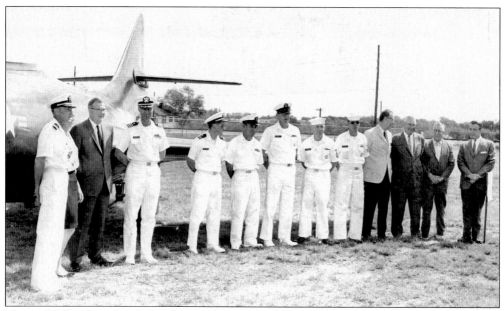

Norma Walker (standing behind the officer on the left) and city officials greet military officers arriving at Buckley Field in the 1960s. The navy acquired the field in 1947 but decommissioned the naval air station on June 30, 1959, at which point the field was returned to the air force. (Courtesy Aurora History Museum.)

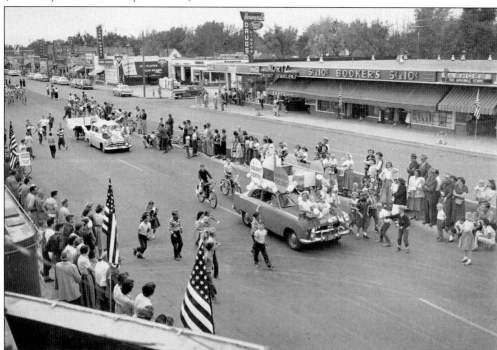

Aurora residents enjoyed parades in the 1950s and 1960s. Generally the high school bands would lead the way, followed by local politicians and floats sponsored by businesses. The parades would usually start in front of the Fox Theatre and travel down Colfax Avenue for several blocks. (Courtesy Aurora History Museum.)

After World War II, the military turned to serious study of the latest technology, bringing it to the military installations around Aurora, most notably Buckley Field. This photograph shows a portion of the inside of the Buckley Field control room in the 1960s. (Courtesy Aurora History Museum.)

A plane taxis down the Stapleton Airport runway in the 1970s. This view was taken from the east looking north. Though having an airport close to the city was convenient, the noise and landing patterns were problems that continually frustrated the people living near the airport along Twenty-fifth Avenue in Morris Heights. (Courtesy Aurora History Museum.)

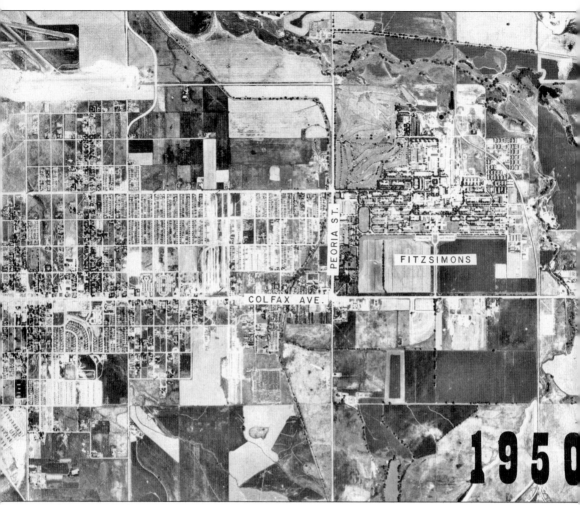

This 1950 aerial photograph, taken at the cross-section of Colfax Avenue and Peoria Street, shows how much of Aurora's land was still undeveloped and empty. Since the city's growth rate was so fast, this changed in just a few years. The top of Fitzsimons Hospital can be seen to the right of Peoria. (Courtesy Aurora History Museum.)

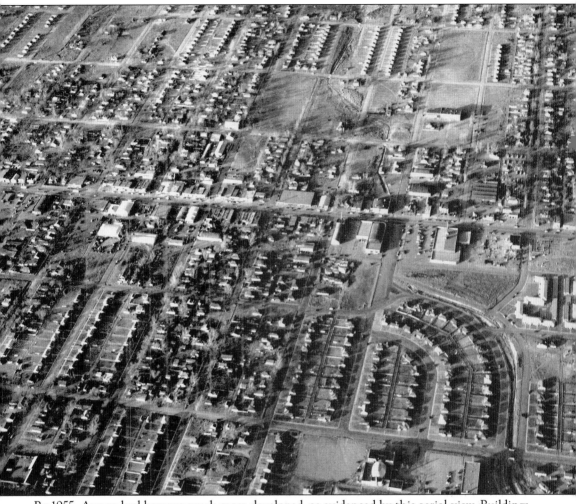

By 1955, Aurora had become much more developed, as evidenced by this aerial view. Buildings and developments were rising up so quickly that city officials were scrambling to keep up with them. The city soon created guidelines for builders to follow to ensure that the community would retain its continuity. (Courtesy Aurora History Museum.)

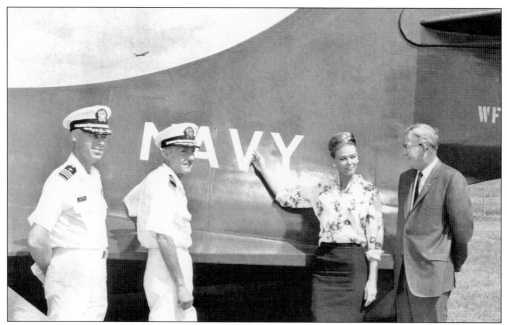

Norma Walker became the first female mayor of a city of over 60,000 inhabitants in 1963, serving until 1967. She reportedly campaigned from house to house toting her youngsters behind in a little red wagon. Once in office, she was instrumental in alleviating some of Aurora's plaguing water issues. (Courtesy Aurora History Museum.)

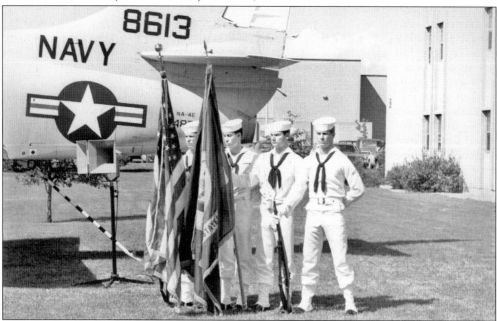

The navy honor guard stands at attention on Buckley Field during a ceremony. This A-4 airplane was used during the Vietnam War. When the field was built, it cost $7.5 million. Base facilities included streets, runways, more than 700 structures, 10 water wells, a water distribution system, a sewage collection and treatment system, an electrical plant, a communication system, a coal-fired steam heating plant, and 16,800 feet of railroad tracks. (Courtesy Aurora History Museum.)

Five

BECOMING A CITY

Aurora was becoming more of a city than a town. While the 1950s and 1960s saw breathtakingly haphazard growth, the 1970s brought its own changes. The number of professional people who lived and worked in Aurora greatly increased throughout the decade. Many Aurorans commuted to jobs in Denver and chose to drive cars instead of using public transportation. One source states that in 1970, Denver had more cars per capita than any other place in the country, which is not surprising due to the lack of public transit options at the time.

The Denver Tramway Company went out of business in 1971. It had provided service to both Denver and Aurora for many years, although the service it gave Aurora hardly reached the outskirts of the growing city. The company was acquired by Denver Metro Transit, which was teetering on the edge of bankruptcy within just two years. It seemed that the area was too spread out to provide good public transportation. However, the oil embargo in 1973 caused public transportation to become popular again. Voters in the metropolitan area, concerned that the cities would grind to a halt, approved the creation of the Regional Transportation District.

At the same time, reports showed that the city council should be putting more effort into luring new industries and businesses to the city, not more residential areas. City leaders were continually troubled over the lack of any major industries except for the form of government in the military posts. The local government soon organized a committee called Explore Commercial Opportunities (ECO) in 1976, designed to approach and persuade corporations to bring their businesses to Aurora. This was not an industrial town, but city government wished to create a wider variety of jobs for residents.

Samuel Hoffman was born in 1901 to a Jewish couple in Russia. He left home while still very young, made his way through a war-torn Europe, and fled to Canada. He learned English while working in a tannery and later entered the United States to become a citizen. For several years, he lived in Detroit, where he learned the plastering and cement-finishing trade. (Courtesy Aurora History Museum.)

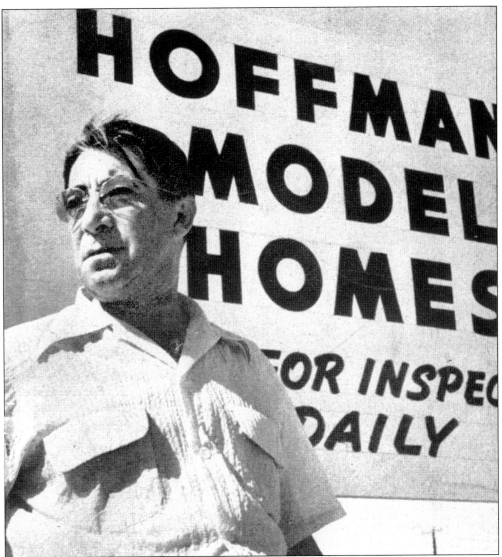

Hoffman was a promoter as well as a builder. He used several innovative tactics that sometimes made him unwelcome among other developers. His houses were quickly built, low cost, and full of up-to-date features. Many were sold before they were completed. (Courtesy Aurora History Museum.)

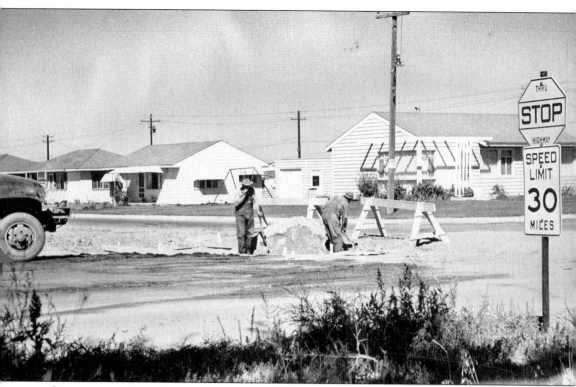

Construction progresses at an intersection in Hoffman Heights. Samuel Hoffman's practice was to employ union labor, preferring apprentices whom he would then teach a specific trade. Each laborer worked on only one specific part of each house; because of this, Hoffman was able to keep costs down and complete the homes in record time. (Courtesy Aurora History Museum.)

Before its development, Hoffman Heights was empty prairie. According to one source, it was originally Union Pacific land. It was later owned by the Platte Land Company and then passed on to the Montgomery Land Company. When Hoffman began building, he constructed several homes along Peoria Street to encourage potential buyers to visit. The ploy worked: many of his homes were sold before they were built. (Courtesy Aurora History Museum.)

For several years, the only high school in Aurora was William Smith. Another facility was opened and called simply Aurora High School; it was later replaced by Central High School and renamed West Junior High. Here cheerleaders pose for the camera in 1967. (Courtesy Aurora History Museum.)

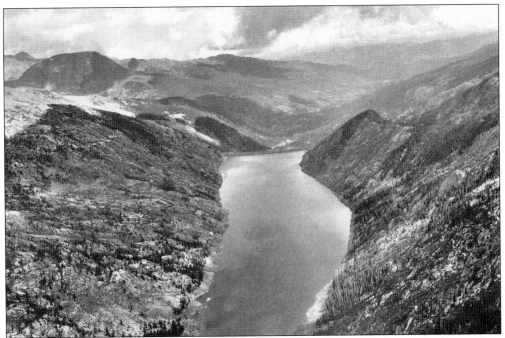

This 1960s photograph shows the Homestake Reservoir, located near Leadville in Eagle County. In July 1963, construction began on Homestake Creek. A 5.2-mile tunnel was driven under the Continental Divide from the reservoir to Turquoise Lake, south of Leadville. The water would flow by gravity through several reservoirs to the South Platte River. From there, it would be piped through the water plant and processed. (Courtesy Colorado Springs Utility Department.)

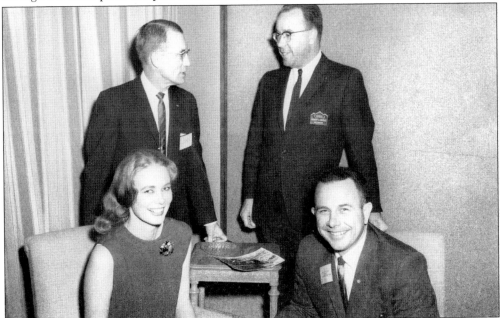

During negotiations regarding the Homestake Project in 1967, Mayor Norma Walker sits on the left, across from Mayor Hoth of Colorado Springs. In the back at right is city manager Robert Wright; the other man is unidentified. (Courtesy Aurora History Museum.)

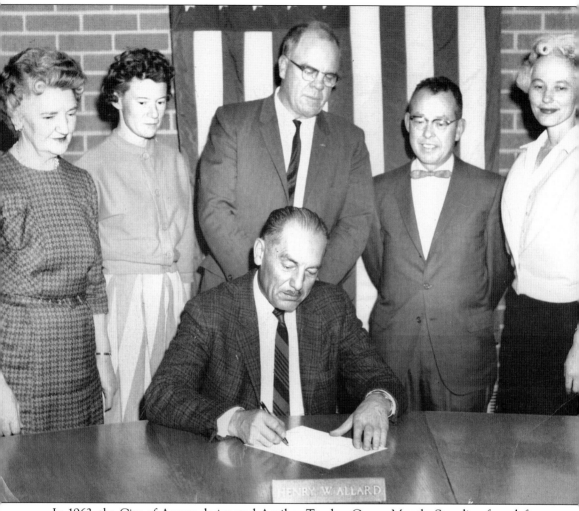

In 1963, the City of Aurora designated April as Teacher Career Month. Standing from left to right are Dora Glenn, Juanita Sparks, superintendent of schools William Hinkley, Ben Swan, and Jeanne Anderson. Mayor Henry Allard sits in front. (Courtesy Aurora History Museum.)

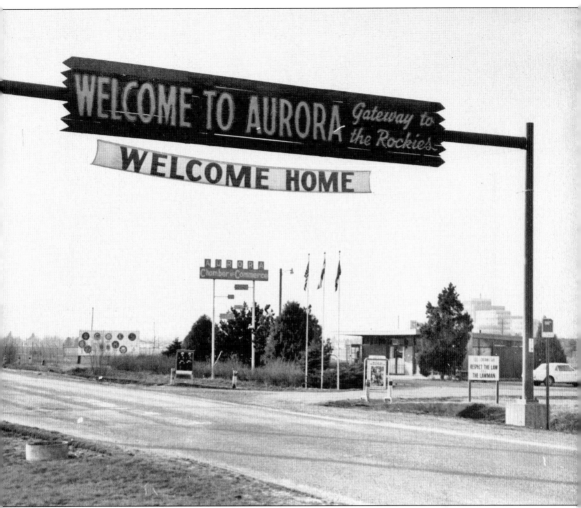

"Welcome to Aurora: Gateway to the Rockies" proclaimed this wooden sign at Potomac Street and Colfax Avenue. It greeted visitors arriving from the east from 1952 to 1983. Locals remember the sign fondly as one of their favorite Aurora landmarks. This view looks west on Colfax Avenue, with the chamber of commerce building on the right. The sign currently sits in the Bicentennial Park. (Courtesy Aurora History Museum.)

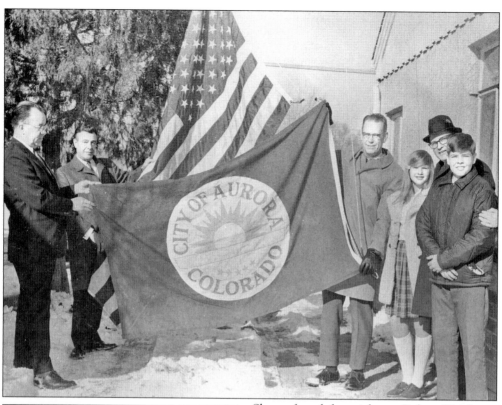

Shown from left to right are Robert Wright, O. James Murray, Mayor Paul Beck, and Irving Brewster of Brewster Realty, with his children. The group is posing with Aurora's city flag on the first day it was flown. Beck became the mayor of Aurora on November 13, 1967. (Courtesy Aurora History Museum.)

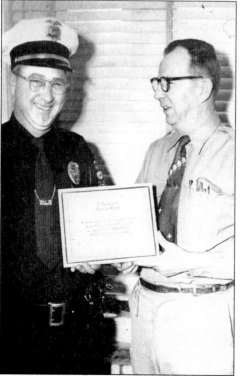

Police chief Spencer Garrett accepts the AAA Award for no pedestrian fatalities in 1952. Presenting the award is Vernon Wildman. Garrett was responsible for the creation of Aurora's modern police department when he became chief in 1949. (Courtesy Aurora History Museum.)

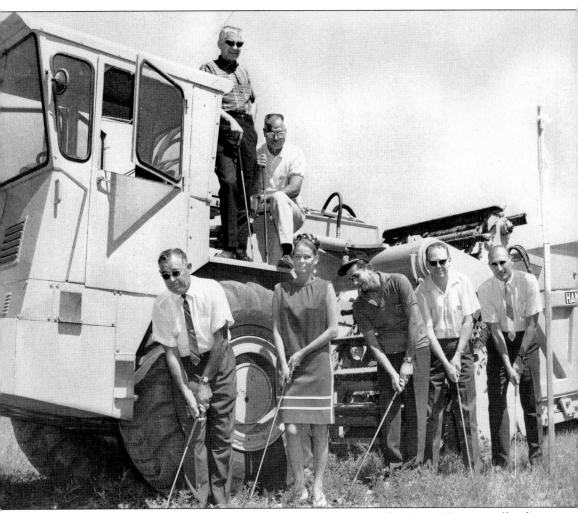

Aurora residents voted for a golf course rather than a hospital in the 1960s. Here city officials gather at the Aurora Hills Golf Course. Pictured from left to right are architect Henry Hughes, Mayor Norma Walker, and councilmen Joel Harris, ? Buch, and Carl Bomholt. (Courtesy Aurora History Museum.)

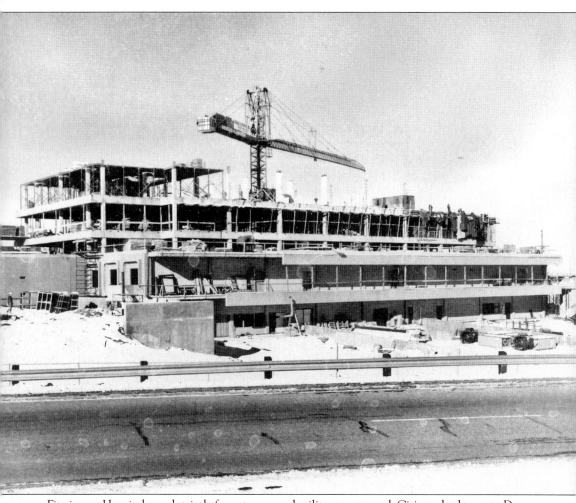

Fitzsimons Hospital cared strictly for veterans and military personnel. Citizens had to go to Denver for medical treatment, since Aurora had no hospital of its own. After almost 20 years of concerned residents working to raise funds and interest, the goal was finally realized. This is the Aurora Heights Presbyterian Hospital under construction. (Courtesy Aurora History Museum.)

Denver hospitals had initially been sufficient for the people of Aurora, but as the population began to swell in the 1970s, they became inadequate. Aurora's population officially reached the 100,000 mark in 1972 with the birth of Brenda Lynn Anderson, who was given 100,000 pennies by local schoolchildren. As a result, Aurora Community Hospital and Aurora Presbyterian Hospital opened their doors in 1975. This photograph pictures construction in progress on Aurora Community Hospital, which later became Humana Hospital and then Aurora Medical Center South. (Courtesy Aurora History Museum.)

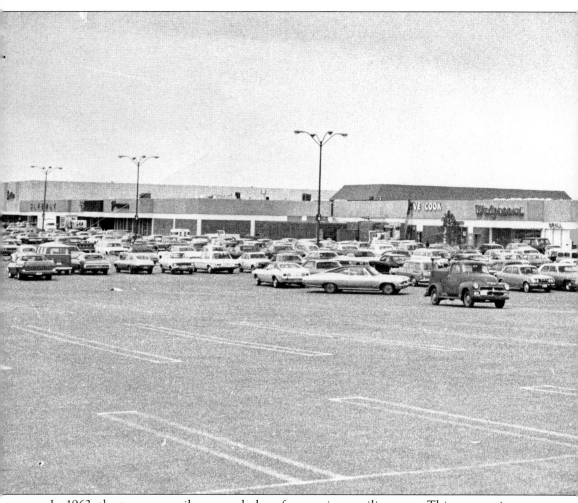

In 1963, the town council approved plans for a major retailing area. This new project was Buckingham Square, one of Colorado's finest shopping malls when it opened in the late 1960s. The mall was to have 65 small shops with two department stores as its anchors. This 1971 photograph

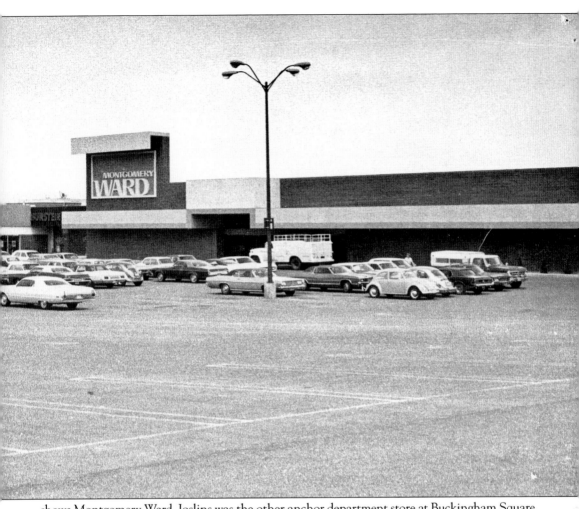

shows Montgomery Ward. Joslins was the other anchor department store at Buckingham Square on Havana Street. (Courtesy Aurora History Museum.)

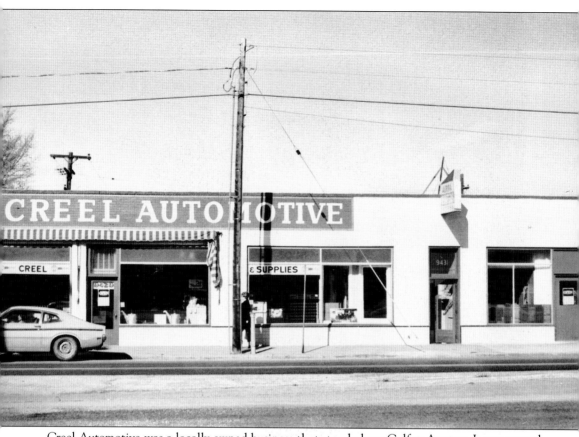

Creel Automotive was a locally owned business that stood along Colfax Avenue. It was owned by Robert Creel, known as a fair employer and businessman. He liked to give youngsters a start, training them to become integral parts of the store. (Courtesy Aurora History Museum.)

After arriving in Aurora in 1925, Lena Barron worked for the town's newspapers for many years. The *Aurora Upstart* was formed in November 1947. A year later, the paper was sold to Olin and Mary Bell Mohler, who renamed it the *Aurora Advocate*. Barron wrote columns for both papers. (Courtesy Aurora History Museum.)

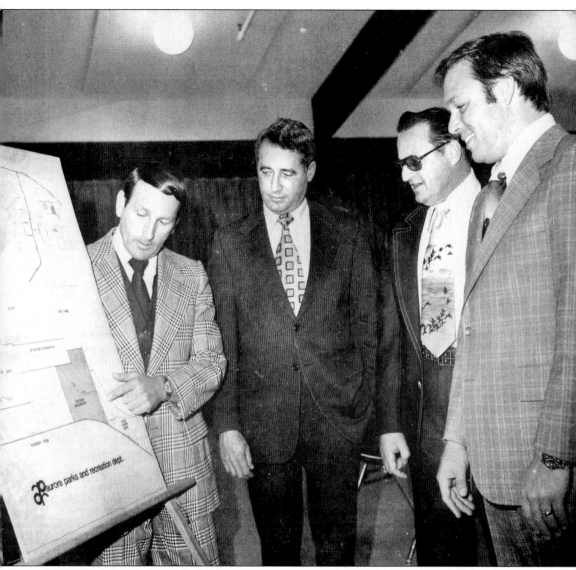

Mayor Fred Hood meets with the Aurora Parks and Recreation Department to plan the creation of new parks within the city limits. Pictured from left to right are Bruce Waldo, Darrell Thompson, Hood, and Michael Norton. (Courtesy Aurora History Museum.)

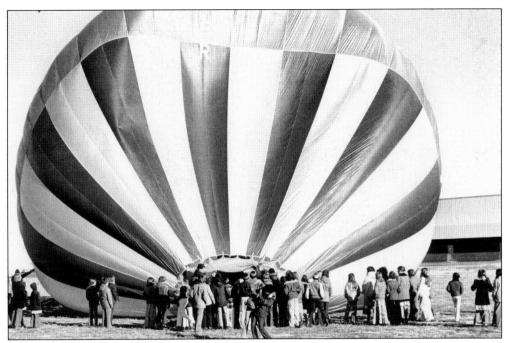

Hot-air ballooning is one of the many things that residents have enjoyed doing in Aurora —and can still do today. Rides are usually given in the morning or evening, when the weather is calmer and cooler. Riders can see the beauty of Aurora from above the treetops. (Courtesy Aurora History Museum.)

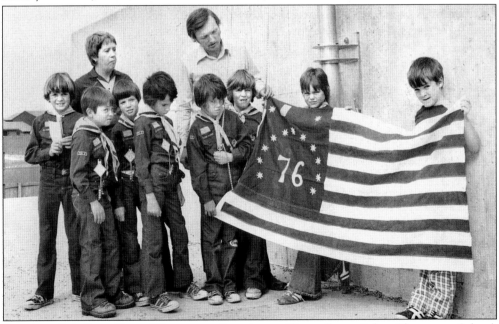

Boys from Cub Scout Troop 741 present a Bennington 13-star flag to Polton Elementary School. From left to right are John Freeland, Scott Hunter, Anthony Bougie, Kevin and Hans Schmidt, Kevin Kellogg, Bret Perlmotter, and David Groth; standing in the back are Principal Bryan Dunn (right) and Cub Scout leader Nancy Freeland (left). (Courtesy Aurora History Museum.)

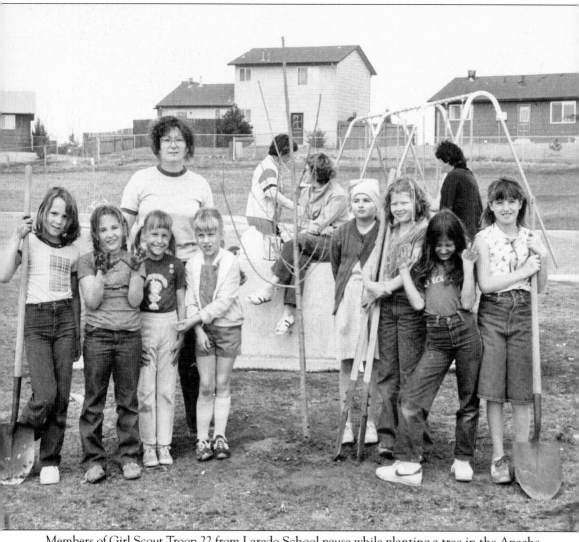

Members of Girl Scout Troop 22 from Laredo School pause while planting a tree in the Apache Park for Community Service Day. Pictured from left to right are Krista VonSeggern, Melinda Daniels, leader Jenny Sanders, Deanna Allace, Kristin Banek, Christina Lilley, Kathy Lilley, Vikki Romero, and Melinda Downing. (Courtesy Aurora History Museum.)

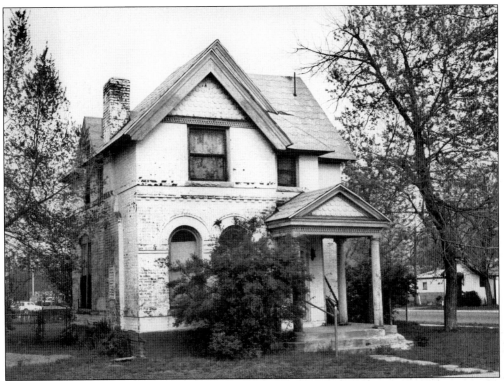

The Centennial House, purchased by the city in 1991, was dedicated as a historic landmark in 1993, about 100 years after the founding of the town of Fletcher. It is one of the original Victorian homes built by Donald Fletcher and his associates and a great example of Queen Anne architecture. (Courtesy Robert Eide.)

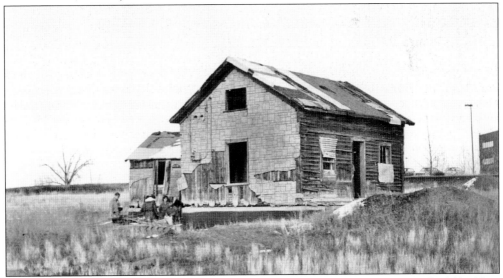

This 1970s photograph reveals the Gully homestead on its original site. The extremely old building was in a state of disrepair, and the Aurora Historical Society moved it to Chambers Road and later to the Delaney Farm. The walls inside were lined with old German newspapers. (Courtesy Aurora History Museum.)

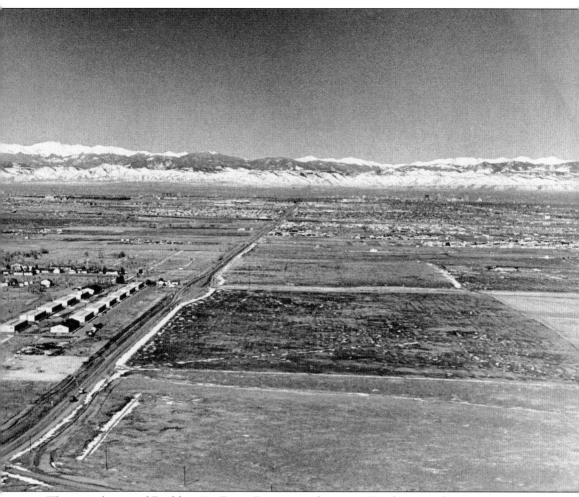

This aerial view of Buckley Air Force Base was taken in 1973, showing the majestic Rocky Mountains rising up in the distance. On April 18, 1960, the installation took on the name Buckley Air National Guard Base, becoming the first stand-alone air national guard base in the country. For the next 40 years, the air national guard would maintain Buckley as an installation. (Courtesy Aurora History Museum.)

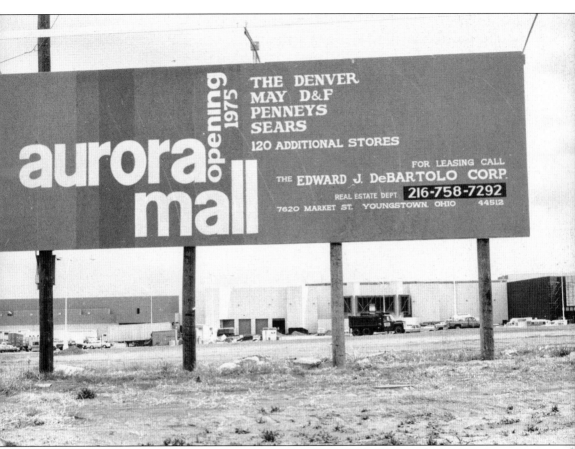

With the construction of the highway system around Aurora, builders took the opportunity to construct a new shopping center near the well-traveled roads. A site was selected for a major mall, and when the Aurora Mall was first built, it was the largest shopping center in East Denver and Aurora. (Courtesy Aurora History Museum.)

Children wave from the trolley during the Bicentennial Park opening in 1976. City officials have always been concerned about keeping the city beautiful and having places for families to relax and enjoy sports, picnics, or other recreational activities. Not only are there several parks throughout the city, there are also natural areas. These include the Delaney Farm, Jewel Wetland, Horseshoe Park, and Sand Creek. The Open Space and Natural Resource Division manages a total of 6,000 acres of woods, trails, and camps. (Courtesy Aurora History Museum.)

The Buckley non-commissioned officers' wives set up a table to collect goods they would later send to soldiers serving in the Vietnam War. Standing around the table from left to right are Kay Silvrants, Brig. Gen. Walter Williams, Jean Shapley, and Jeanne Sharpley. (Courtesy Aurora History Museum.)

Paul Tauer was Aurora's first full-time mayor. He was elected in 1987, when the mayor's job was only part-time. In 1993, the City of Aurora voted to change the mayor's job to full-time instead of part-time. Tauer then left his teaching job to turn his full attention to the needs of the city. He was instrumental in the redevelopment of Lowry Field and Fitzsimons Hospital when both were closed by the government. (Courtesy Aurora History Museum.)

William Hinkley was only a boy when he first visited Aurora. He worked a lot of odd jobs as he was growing up, and he also learned to fly. He worked as a pilot for Eastern Airlines, helping to train other pilots on the instruments. In 1947, Hinkley was offered the job of superintendent for Aurora public schools. He decided to stay where he was, but in 1949, he finally accepted the position, which he held until his retirement in April 1968. He went on to become a lobbyist for Colorado school districts and did not actually retire until 1971. Hinkley High School was named for him. (Courtesy Aurora History Museum.)

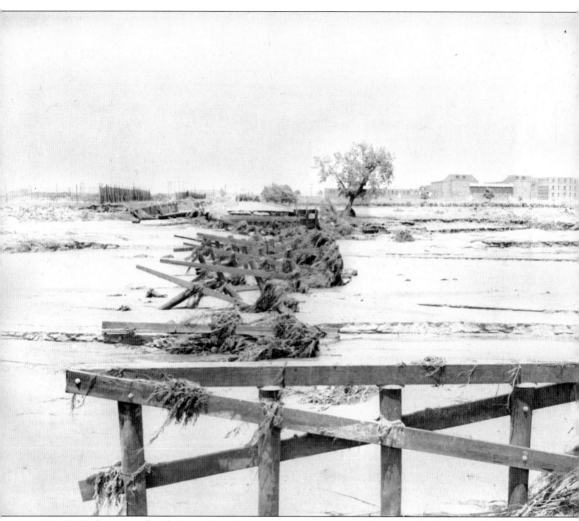

In 1965, the worst flood Aurora had seen in many years wiped out the bridge over Sand Creek at Peoria Street. Juanita Sparks remembers how the water literally came toward her like a wall, destroying everything in its path. (Courtesy Aurora History Museum.)

Six

LOOKING TO THE FUTURE

Rumors were always afoot that one of the military installations around Aurora was slated for closure. The federal government followed strict principles of cost-effective management, and the Base Reassignment and Closure (BRAC) committee started closing bases throughout the country. As Aurora headed into the 1980s, it was losing its reputation as a military suburb. Since more commercial development had taken place in the past couple of decades, there were more jobs for residents, and the possibility of Fitzsimons or one of the bases closing was not as daunting as it would have been years earlier.

Lowry Technical Training Center shut down in 1994. Mayor Paul Tauer served as co-chairperson on the Lowry Redevelopment Association with Mayor Wellington Webb of Denver. The group came up with a plan to reintegrate the air force base into the community. Plush modern homes and apartment buildings took the place of the former Lowry Technical Training Center, along with the Wings of the Rockies Museum and other businesses.

In 1995, Fitzsimons Army Medical Center was put on the list. Though Aurora no longer relied heavily on the hospital to provide jobs, officials were still concerned to see it go. They fought the closure with everything they had, to no avail.

What was to be done with the 690-bed hospital and all the buildings that had been a part of the installation? The worst-case scenario was that the structures would be boarded up. The area still suffered from economic blight, though the city started several projects in an attempt to clean and beautify old Colfax Avenue.

City officials immediately began work on a plan to salvage the property. Paul Tauer went to the University of Colorado, having heard that the City of Denver had turned down its petition to expand the campus. If everything worked out, the university could use the hospital facilities—as long as the army and several other entities approved. Paul Tauer himself made multiple trips to Washington, D.C., to speak with the Department of Defense and congress members on behalf of the Fitzsimons Redevelopment Authority.

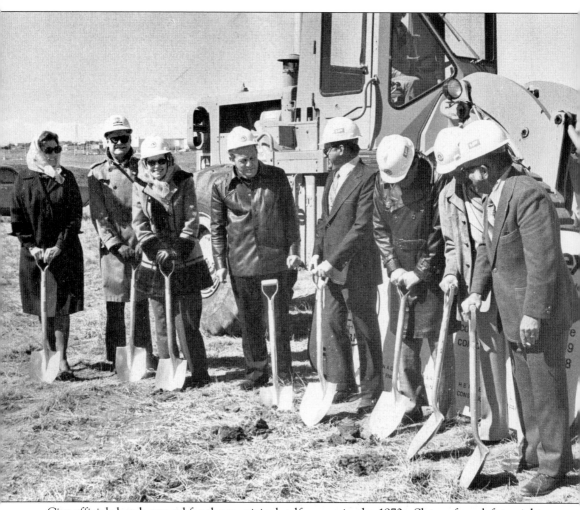

City officials break ground for the municipal golf course in the 1970s. Shown from left to right are Ruth Fountain, Robert Semple, Alice Dudich, John Sutera, Fred Hood, William Cobern, and two unidentified men. Aurora now has several other public and private golf courses, including Aurora Hills, Meadow Hills, and Murphy Creek. (Courtesy Aurora History Museum.)

Mrachek Middle School was named for Ellin Mrachek and her husband, Col. Harry Mrachek. The Mracheks were heavily involved with the community. Ellin taught as a substitute and also worked passionately to establish a vocational and technical school. She was the driving force to establish the Community College of Aurora, the Aurora Mental Health Center, and T. H. Pickens Vocational Technical School. She was a member of the Aurora Public School board for many years. (Courtesy Aurora History Museum.)

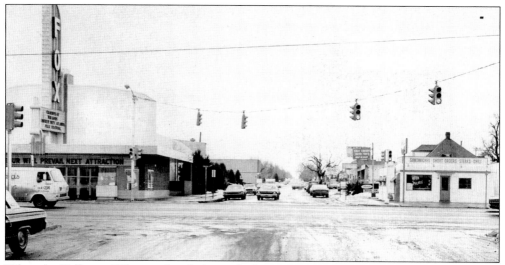

When the Hollywood Theatre closed, Aurora had no movie venue until the Fox Theatre was built in 1946. Lt. Col. Homer Preston lobbied for enough materials to build a theater and was given a Quonset hut from Lowry to use for the theater. It provided an interesting, attractive theater for Aurora. This snapshot of Colfax Avenue in 1973 shows the Fox Theatre on the left. (Courtesy Aurora History Museum.)

Paths along the High Line Canal were first created in the early 1900s. The trails were first used by riders who would inspect the canal. Today the trails are pleasant places to walk, jog, or ride a bicycle. Here horseback riders amble along the canal near South Middle School in the 1980s. (Courtesy Aurora History Museum.)

East Colfax Avenue's place as downtown Aurora diminished after the 1950s. It became a disreputable place, a street that many citizens made it a point to avoid. City planners began several urban renewal projects to return Colfax Avenue to its former reputation. Despite their efforts, Colfax Avenue remained disreputable from the 1960s through the 1990s. The Colfax Concourse was completed in the late 1970s in an attempt to beautify the street. This fountain is at the corner of Colfax Avenue and Florence Street. (Courtesy Aurora History Museum.)

Since the inception of Aurora as the town of Fletcher, setting aside land for parks and recreation has been very important. City officials listed a park as one of the requirements for developers in the 1960s and 1970s. Today the Parks Operation and Management Division oversees a total of more than 1,800 acres of land in 108 parks in the city. (Courtesy Aurora History Museum.)

In the 1950s and 1960s, Aurora citizens attempted to establish a junior college district. The group's proposal was rejected, but the Aurora Technical Center was opened by Aurora Public Schools in 1972. The Community College of Denver began offering night classes at Hinkley High School in 1972, but the Community College of Aurora was not ultimately created until 1983. (Courtesy Aurora History Museum.)

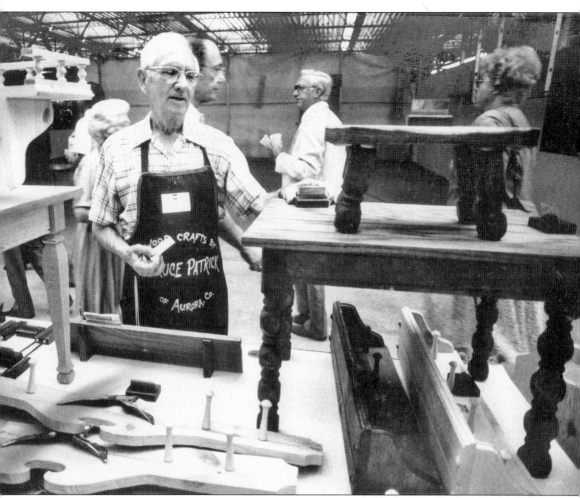

Bruce Patrick displays his woodwork in one of the many booths and shops inside the public market of Aurora. In addition, various farmers' markets have been located around the city. One of the main locations today is in the parking lot of the old Fan Fare building on Havana Street. (Photograph by Randy Tobias; courtesy Aurora History Museum.)

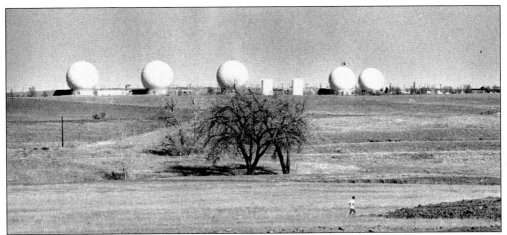

This photograph shows the radar domes near Buckley. In October 2000, Buckley's ownership reverted to the U.S. Air Force, and the secretary of the air force renamed the facility Buckley Air Force Base. In addition to its active-duty air force population, the 3,897-acre military base hosts army, navy, marine corps, coast guard, and national guard and reserve personnel. More than 12,000 military civilians and contractors work at the installation. (Courtesy Aurora History Museum.)

A field blast deflector, seen here, is used to test jet engines on Buckley Field. When the experiment was first attempted, using steel, the deflector failed. It was then constructed of old railroad tracks, designed and fabricated by Sergeants Hesten and McHood. (Courtesy Aurora History Museum.)

Named for Aurora's primary founding father, Fletcher Plaza sits at the heart of Old Colfax Avenue. Plans have been in place since 1992 to renew the area, the center of original Aurora. The Colfax Main Street Master Plan was adopted in 1996 by the City of Aurora and has since reinvented the street as an art district. (Courtesy Robert Eide.)

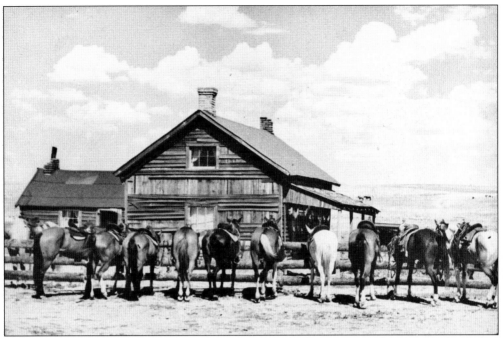

This photograph shows the Gully family's house in the 19th century. By the time of John Gully's death in 1915, he had a ranch that covered 11,020 acres. His widow and children struggled to keep the farm open, but eventually the land was sold to pay off some of their debts. In the image below, the Gully house has been restored to its classic cottage style, the remodeling completed in 1984 by the Little Curry Crew. (Courtesy Aurora History Museum.)

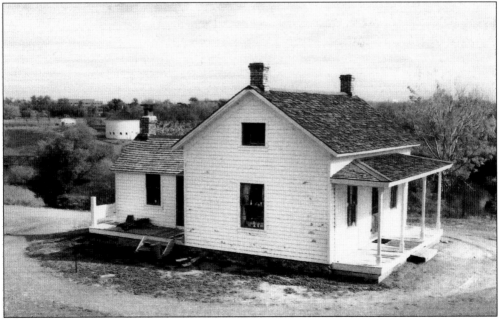

The Gully house is shown here in the 20th century at its present location in the Delaney Farm Historic District along Chambers Road. It was donated to the City of Aurora by family descendants. (Courtesy Robert Eide.)

The city council came to the conclusion that a new municipal building was needed, one that was befitting the dignity of the government of the third largest city in the state of Colorado. Completed in 2003, the 280,000-square-foot building is a monument to the city of Aurora. (Courtesy Robert Eide.)

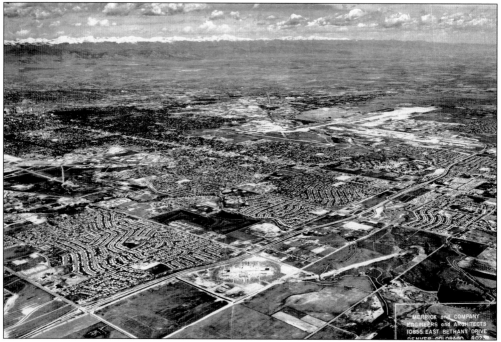

This aerial view of Aurora looks northwest toward the mountains. The Aurora Mall can be seen in the center of the image's lower half. The city that began as just four square miles is now the 59th most populous in the country. (Courtesy Aurora History Museum.)

BIBLIOGRAPHY

Aurora Democrat-News. Aurora, CO: 1909.

Aurora: the First 40 Years. Aurora, CO: Aurora Historical Society, 1981.

Dale, John. "Ellin Mrachek." Unpublished article.

Eide, Robert. "Aurora Movie Houses Have Had Checkered Career." *Advocate*, May 2006.

———. "Aurora's Most Hectic Five Minutes." *Advocate*, March 2007.

———. "96 Years of Aurora Newspaper History." *Advocate*, November 2005.

Fitzsimons Army Hospital. Aurora, CO: Aurora Historical Society, 1983.

Historic Aurora House and Garden Tour: Chambers Heights. Aurora, CO: Aurora Historical Society, 1986.

Historic Aurora House and Garden Tour: Hoffman Heights. Aurora, CO: Aurora Historical Society, 1984.

Historic Aurora House and Garden Tour: Village East. Aurora, CO: Aurora Historical Society, 1988.

Mehls, Steven F., Carol J. Drake, and James E. Fell Jr. *Aurora: Gateway to the Rockies.* Evergreen, CO: Cordillera Press, 1985.

ACROSS AMERICA, PEOPLE ARE DISCOVERING SOMETHING WONDERFUL. *THEIR HERITAGE.*

Arcadia Publishing is the leading local history publisher in the United States. With more than 4,000 titles in print and hundreds of new titles released every year, Arcadia has extensive specialized experience chronicling the history of communities and celebrating America's hidden stories, bringing to life the people, places, and events from the past. To discover the history of other communities across the nation, please visit:

www.arcadiapublishing.com

Customized search tools allow you to find regional history books about the town where you grew up, the cities where your friends and family live, the town where your parents met, or even that retirement spot you've been dreaming about.